신선미의 한복유희

신선미의 한복유희(韓服遊戱)

2017년 6월 17일 초판 1쇄 발행
2022년 5월 20일 초판 4쇄 발행

그림·글 신선미
번역 이경희
영문 감수 Teresita M.Reed

펴낸이 임상백
기획편집 함민지
디자인 이혜희, 정든해
제작 이호철
마케팅 이명천, 장재혁, 김태운
경영지원 남재연

ⓒ 신선미, 한림출판사 2017

ISBN 978-89-7094-973-4 03650

펴낸곳 한림출판사
주소 (03190) 서울특별시 종로구 종로12길 15
등록 1963년 1월 18일 제 300-1963-1호
전화 02-735-7551~4
전송 02-730-5149
전자우편 hollym@hollym.co.kr
홈페이지 www.hollym.co.kr

신선미의 한복유희

그림·글 신선미

한림출판사

The Artist's Statement

"I was frequently ill and bedridden when I was young. So often I would awaken from sleep to find myself gazing at darkness in the middle of the night, fall back to sleep, wake up again in the morning, feeling hazy, when I would see tiny fairies. The fairies played and then disappeared into a corner a while later. Nobody else but I could see them. The adults said they were worried as I was driveling out of confusion between my dreams and reality. But I still vividly remember those fairies. Always they would move in groups, never being caught by adults. Maybe, the adults weren't able to see fairies because they weren't interested in them at all."

From the artist's working notes

"Ant fairy" was the name I gave the small fairies because they just looked like ants moving about between cracks and chinks of surfaces. I still remain confused whether I saw them in my dreams or in reality, but my experiences from those days have become good material in my art. It's already been ten years since I began working on the theme of ant fairy stories, but there has been a little difference between my paintings done before and after my marriage.

In my earlier works, the fairies only appear while adults are sleeping; they play with cats, creating comic scenes like Tom and Jerry. But the stories in my paintings began to expand greatly after I got married and gave birth to my child. The stories were about my child seeing the fairies that I used to see when I was young but can no longer see.

My son in my paintings becomes friends with the fairies, without any sign of wariness, and he even protects them from a cat. As he grows up, however, he begins to lose interest in the fairies and turns to other games. The fairies are frustrated but recall his mother whom they had first met. They summon up memories of her in her childhood.

My recent paintings deliver stories about my faint memories that are unfolded as I rediscover myself as a child while watching my son grow up. But I have learned many things giving birth to my child and raising him. And I know I have more stories to tell in my paintings. I am thankful to my son for creating precious memories in both my life and my work.

작가의 말

"어린 시절, 잦은 병치레로 누워 지낸 시간이 많았다. 자다 깨면 밤이고 또 자다 깨면 아침인 몽롱한 상황 속에서 나는 작디작은 요정들을 보았다. 잠시 놀다 구석으로 사라지는 그들을 나 외엔 아무도 보지 못했다. 어른들은 내가 꿈과 현실을 혼동하여 헛소리를 한다며 걱정했지만, 나는 아직도 그때의 일을 생생히 기억한다. 그들은 늘 무리 지어 다니면서도 절대 어른들 눈에 들키지 않았다. 어쩌면 어른들은 요정이란 존재에 관심조차 두지 않았기 때문에 볼 수 없었던 것은 아닐까?"

- 작업노트 中 -

개미요정, 틈 속을 숨어 다니는 모습이 꼭 개미처럼 보여서 그렇게 이름 붙였다. 그때 보았던 그들이 꿈인지 현실인지 아직도 헷갈리지만, 이때의 경험이 작품의 알찬 소재들이 되고 있다. 어느덧 10년에 접어든 '개미요정 이야기' 작업은 결혼 전과 후의 이야기에서 조금 차이가 있다.

초기 작품에서는 어른이 잠든 사이에만 나타나는 개미요정들은 고양이와 마치 '톰과 제리'처럼 코믹한 이야기를 만들어냈다. 하지만 결혼 후 내게 아이가 태어나면서부터 그림 속 이야기는 크게 확장되기 시작했다. 내가 어린 시절 보았던, 하지만 이제는 보지 못하는 개미요정을 다시 나의 아이가 보게 된다는 이야기가 그것이다.

그림 속에 등장하는 나의 아들은 아무런 경계심 없이 요정과 친해지고, 요정들을 고양이로부터 보호해주기도 한다. 하지만 아이는 조금씩 커가면서 다른 놀이를 즐기며 개미요정들을 외면하기 시작한다. 개미요정들은 아이의 외면에 속상해하다 맨 처음 만났던 아이의 엄마를 떠올린다. 그리고 다시 '어린 시절 모습의 엄마'를 불러낸다.

최근의 작품들은 커가는 아들을 보며, 어릴 적 나를 발견하며 풀어내는 아련한 추억 이야기라고 할 수 있다. 아이를 낳고, 키우는 동안 나는 많은 걸 배웠다. 또 내 작품 속 이야기도 풍부해졌다는 것을 알겠다. 내 삶과 작품 속 모두에 소중한 추억을 만들어준 우리 아들에게 고맙다고 말해야겠다.

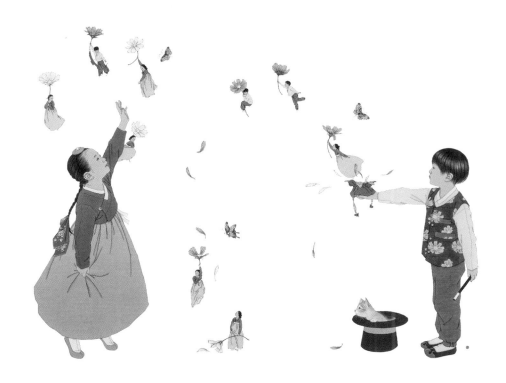

Contents

My Amnesia and Ant Fairies

I frequently experience having things around me disappear.
Every time I find them after searching around here and there,
I just say, "Well, who has brought this back here?"
I think of any excuse because I cannot remember.
Sometimes I rummage through piles of old stuff to look for a small thing.
Then I look around the messy room, saying to myself, smirking,
"Wow, how can you clean up all this?"
The moment I stand up shaking the dust off my pants,
A worn-out chest behind a broken box comes into sight. A very old one.
A ragged, shabby chest of drawers covered with scribbles I wrote when I was young.
Why is it still here? What attachment did it have so I haven't thrown it away until now?
I squat down next to the chest, gazing at it for a long while.
As if drawn by something, I look under the chest.
Then I see some afterimages swiftly passing by, and hear a familiar sound of laughter.
I recall I came across them right here a long time ago.
Who were they?
Was I dreaming......

나의 건망증 그리고 개미요정

내겐 물건들이 사라지는 일이 자주 일어난다.

한참을 이리저리 뒤적이다 겨우 찾아낼 때면,

"어, 누가 여기에 가져다 놓았지?" 이러고 만다.

기억이 잘 안 나니까, 다른 핑계 거리를 찾는 것인지도 모르겠다.

가끔 물건 하나 찾는다고 묵은 짐들을 다 헤집어놓기도 했다.

어질러진 방을 보면 '이걸 언제 다 치우려나' 혼잣말에 헛웃음이 섞여 나왔다.

바지에 묻은 먼지를 털며 일어서려던 그때,

무너진 박스 뒤로 낡은 서랍장이 눈에 들어왔다. 아주 오래된 것이었다.

어린 시절의 낙서가 잔뜩 그려진 낡고 볼품없는 서랍장.

왜 아직 여기 있는 건지, 나는 무슨 미련으로 이걸 여태껏 버리지 못한 건지.

나는 그 앞에 쭈그리고 앉아 서랍장을 한참 바라보았다.

그리고 무언가에 이끌리듯 한쪽 얼굴을 바닥에 대고 서랍장 아래를 들여다보았다.

순간 빠르게 스치는 잔상들, 그리고 언젠가 들은듯한 웃음소리.

오래전 바로 이곳에서 마주쳤던 그들이 떠올랐다.

그들은 누구였을까?

꿈이었을까……

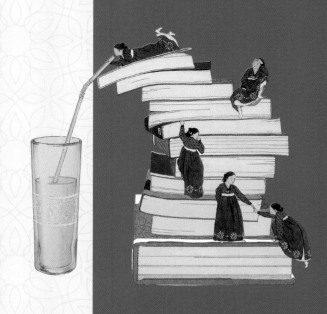

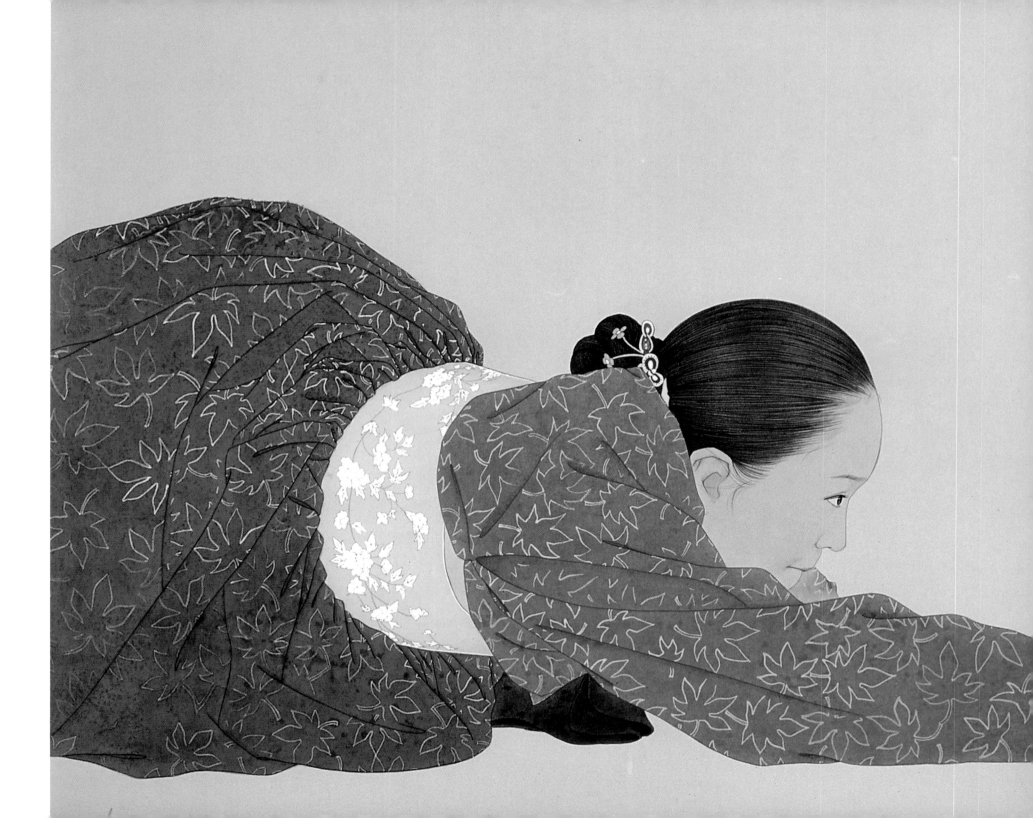

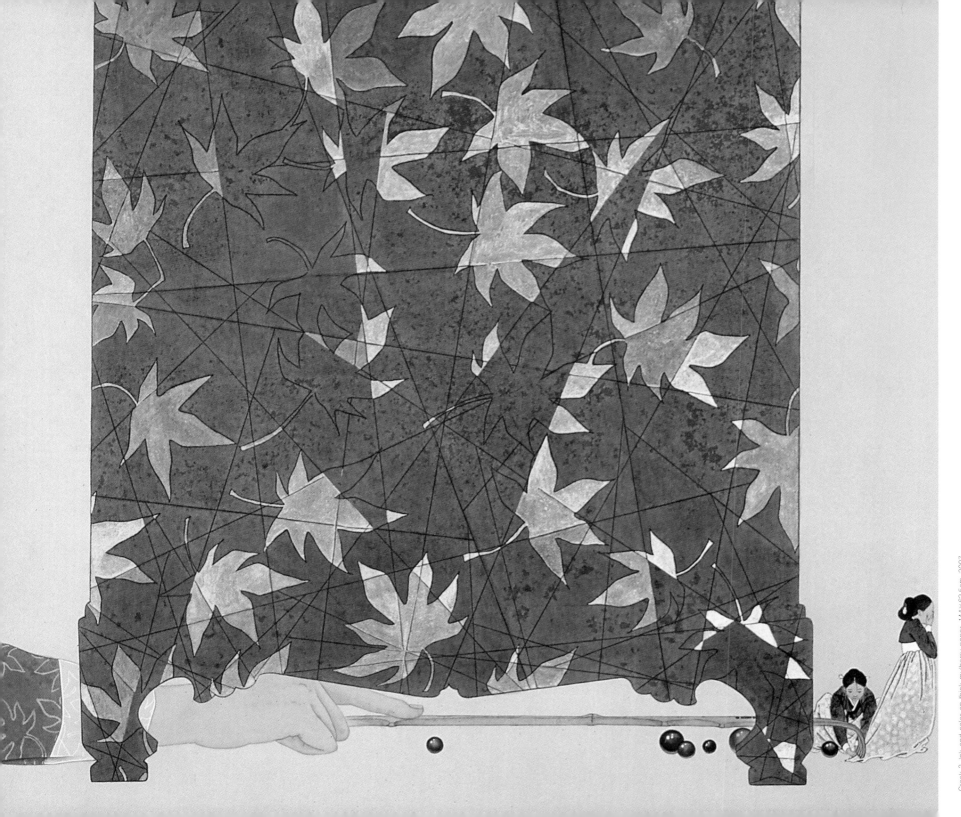

Crack 2. Ink and color on thick mulberry paper, 144×63.5cm, 2007.
틈 2 144×63.5 장지에 채색 2007

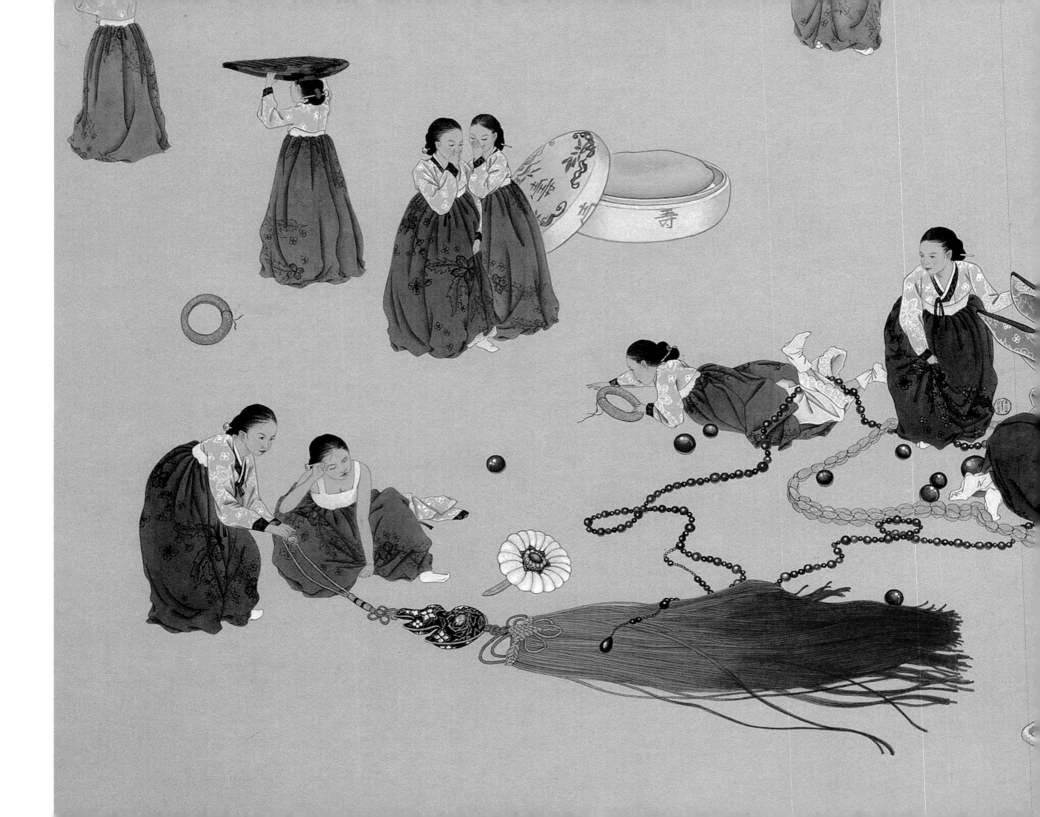

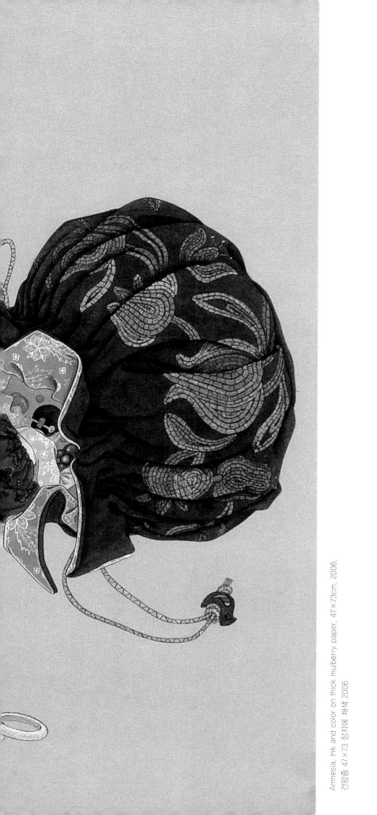

Amnesia. Ink and color on thick mulberry paper. 47×73cm. 2006.
건망증 47×73 장지에 채색 2006

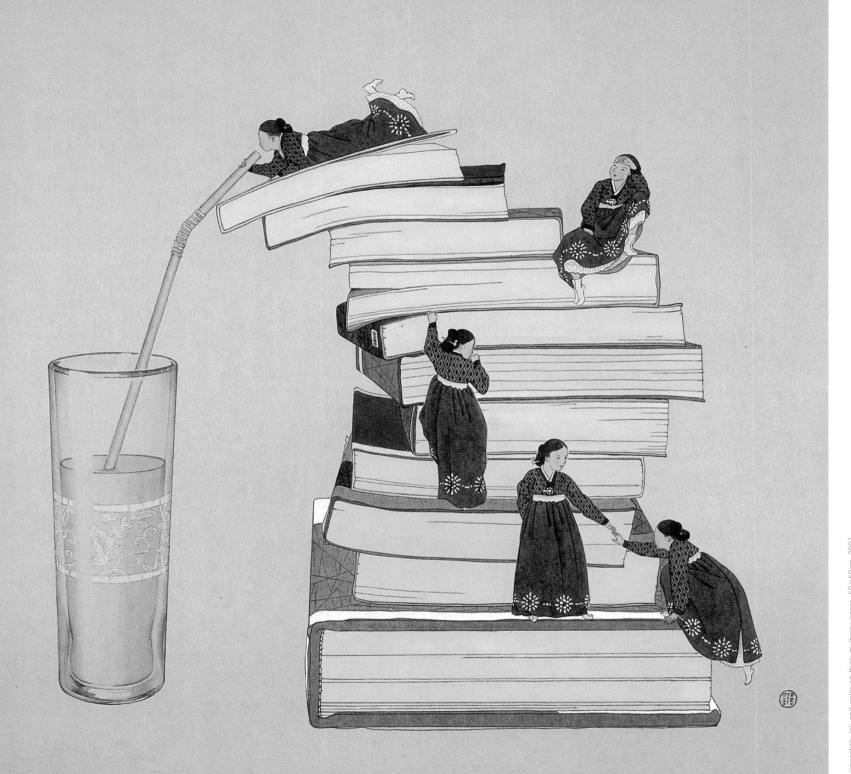

Evaporation. Ink and color on thick mulberry paper. 50×50cm. 2007.
증발 50×50 장지에 채색 2007

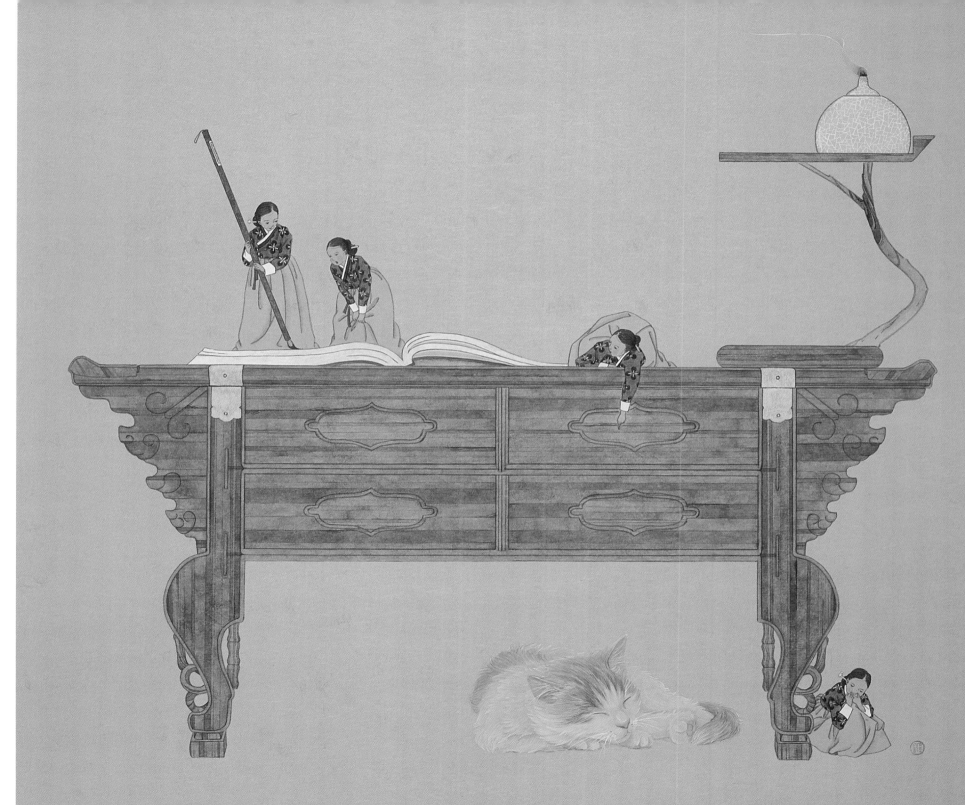

Trace, ink and color on thick mulberry paper, 57×66cm, 2008,
흔적 57×66 장지에 채색 2008

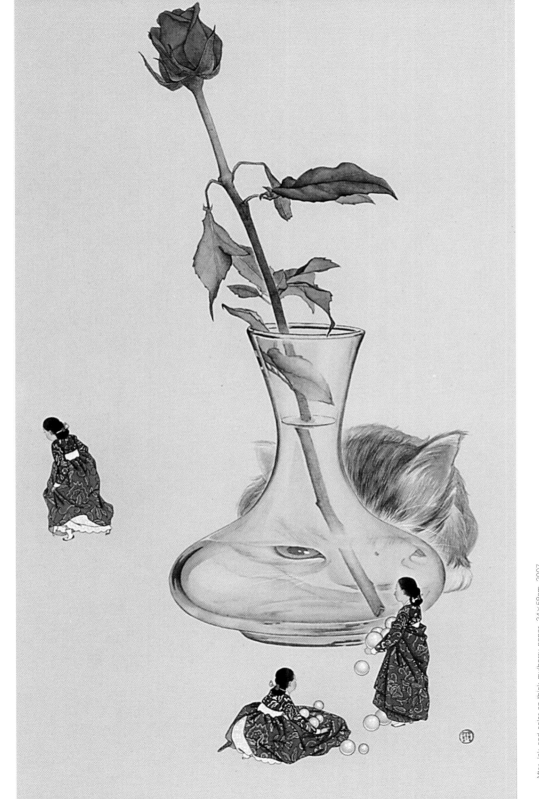

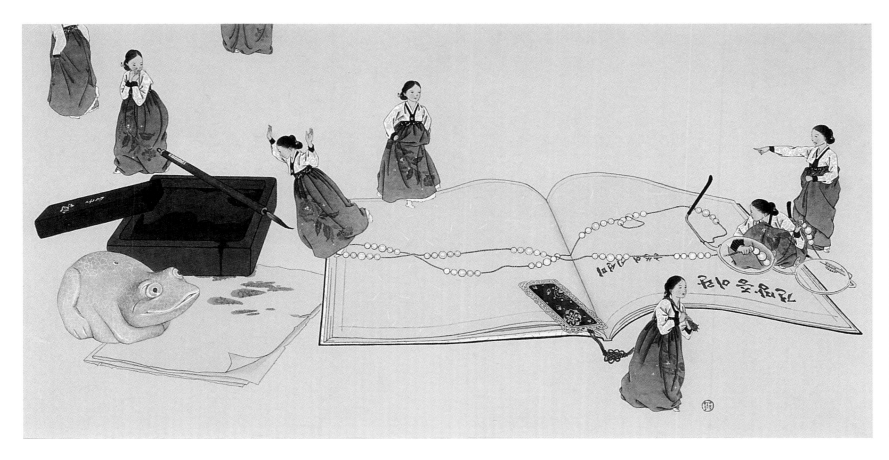

Amnesia, Ink and color on thick mulberry paper, 35×70cm, 2008.

건망증 35×70 장지에 채색 2008

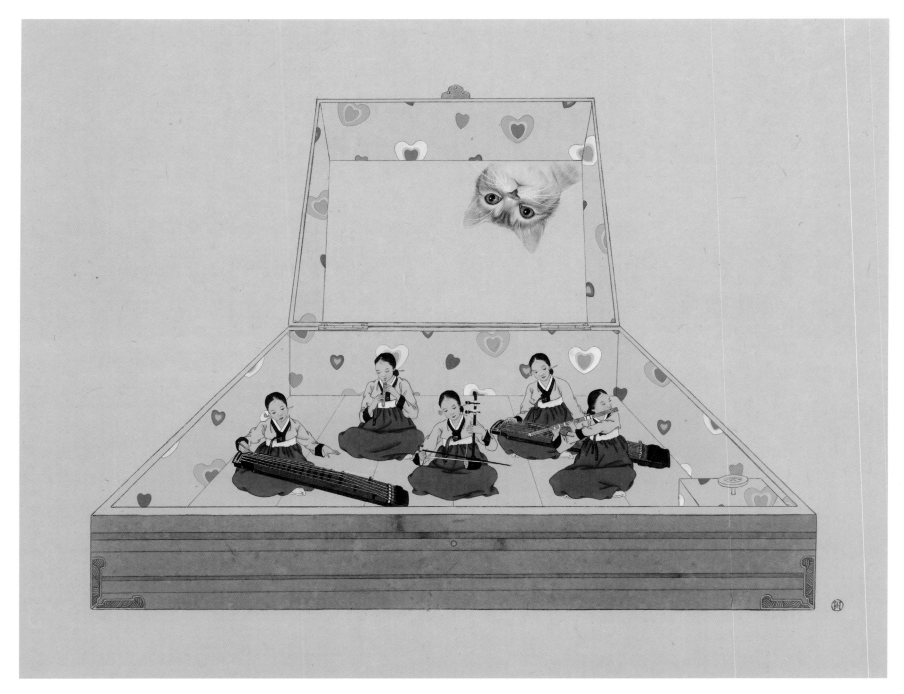

Orgel 3, Ink and color on thick mulberry paper, 56×73cm, 2010.
오르골 3 56×73 장지에 채색 2010

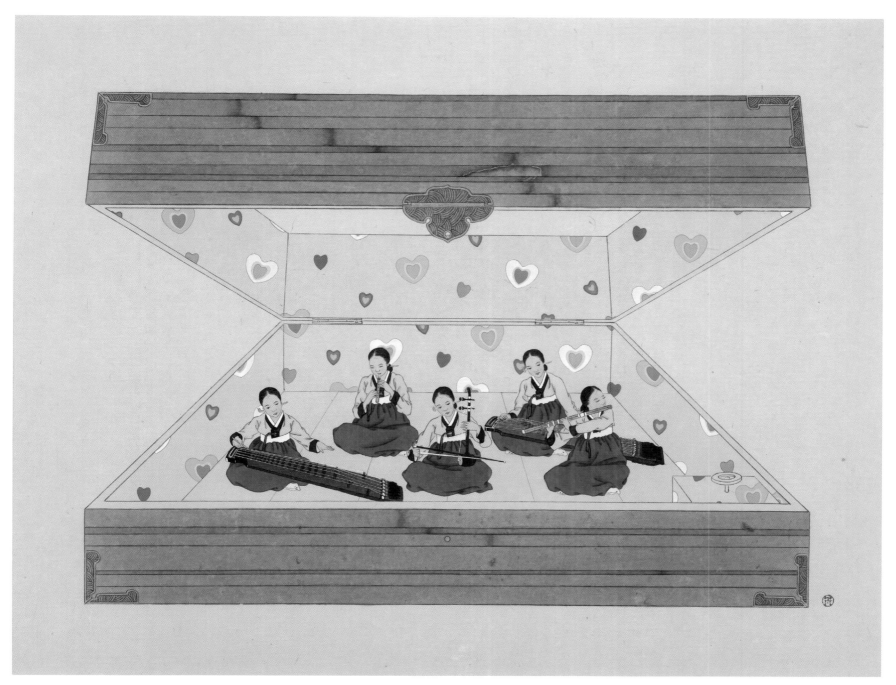

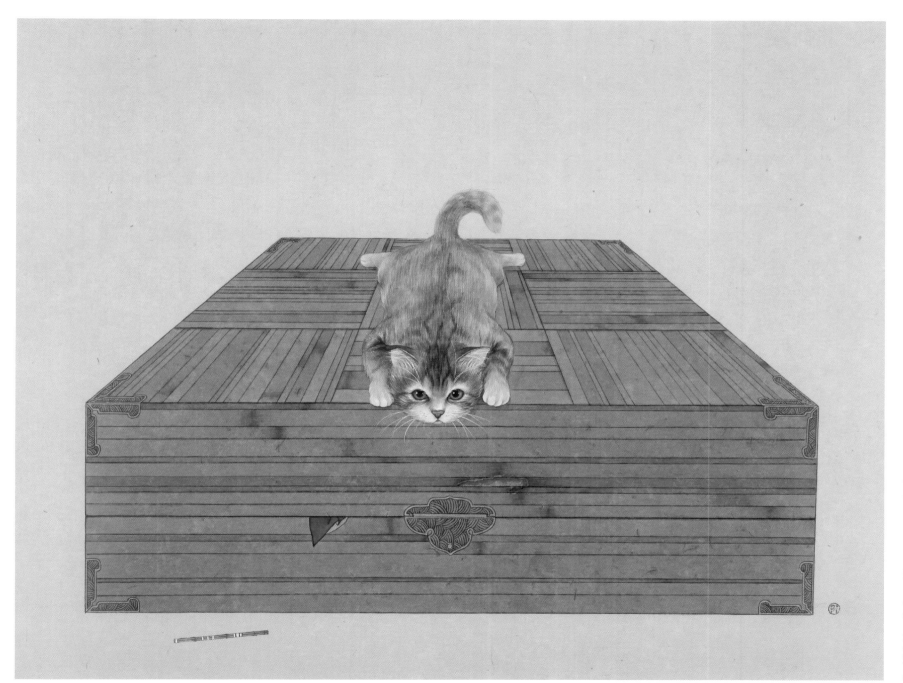

Orgel 3-3, Ink and color on thick mulberry paper, 56×73cm, 2010,
오르골 3-3 56×73 장지에 채색 2010

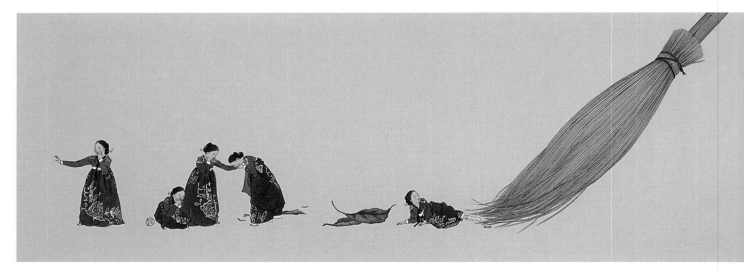

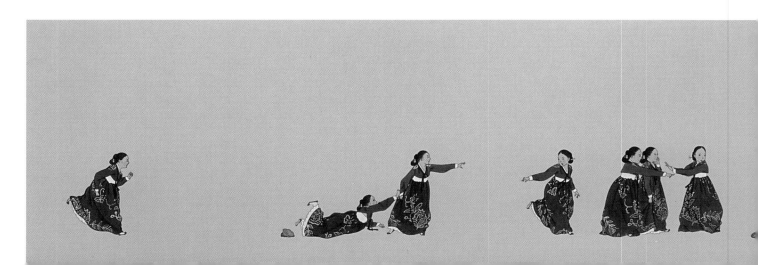

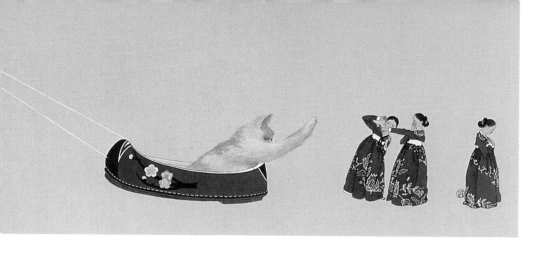

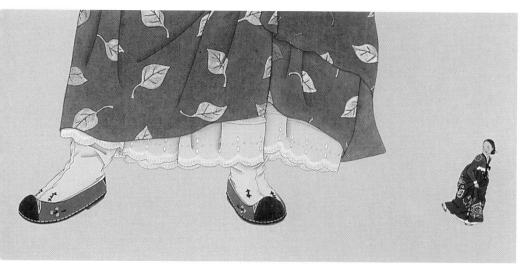

Dizzy Ouling. Ink and color on thick mulberry paper, 147.5×30cm (each). 2007.
어찔한 외출 147.5×30×3 장지에 채색 2007

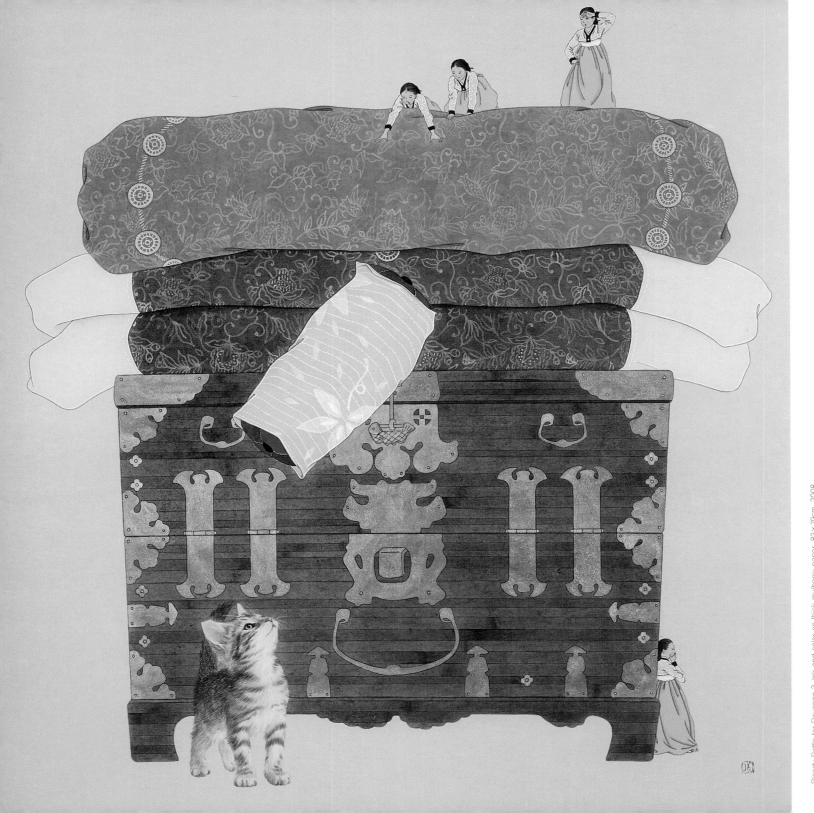

Bloody Battle for Revenge 3, ink and color on thick mulberry paper, 82×79cm, 2008.
복수혈전 3 82×79 장지에 채색 2008

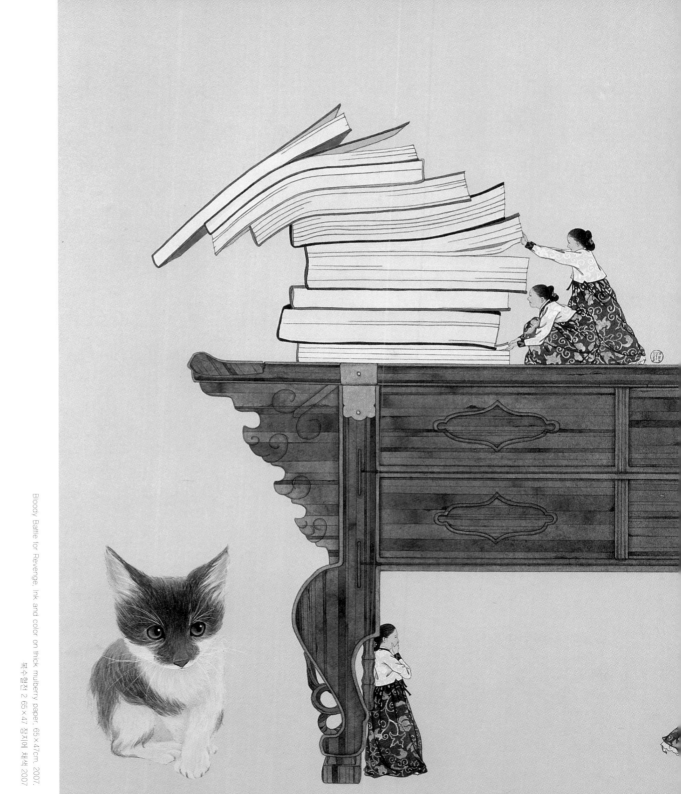

Bloody Battle for Revenge, Ink and color on thick mulberry paper, 65×47cm, 2007.
특수혈전 2 66×47 장지에 채색 2007

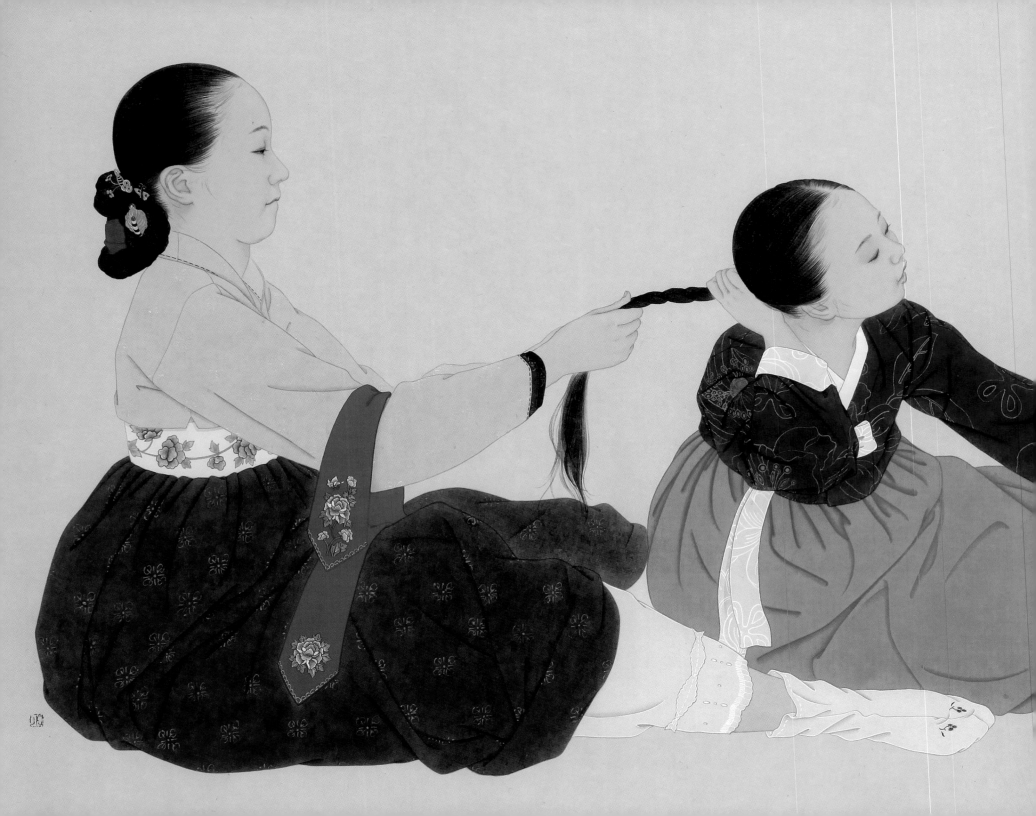

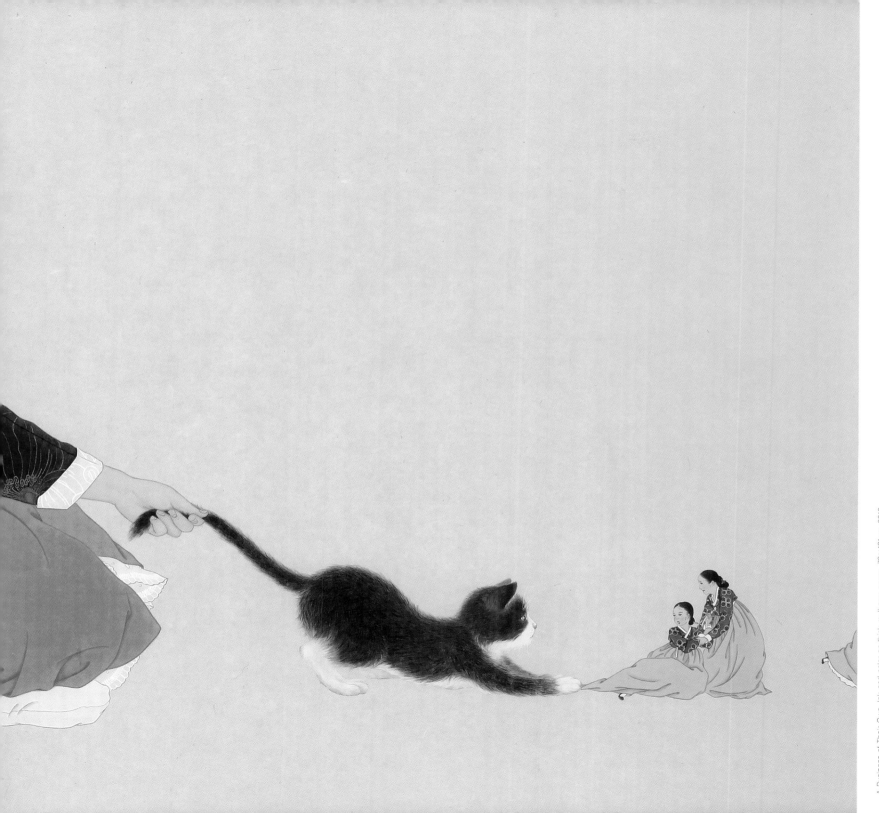

A Business of Their Own, Ink and color on thick mulberry paper, 79×181cm, 2010,
그들만의 사정 79×181 장지에 채색 2010

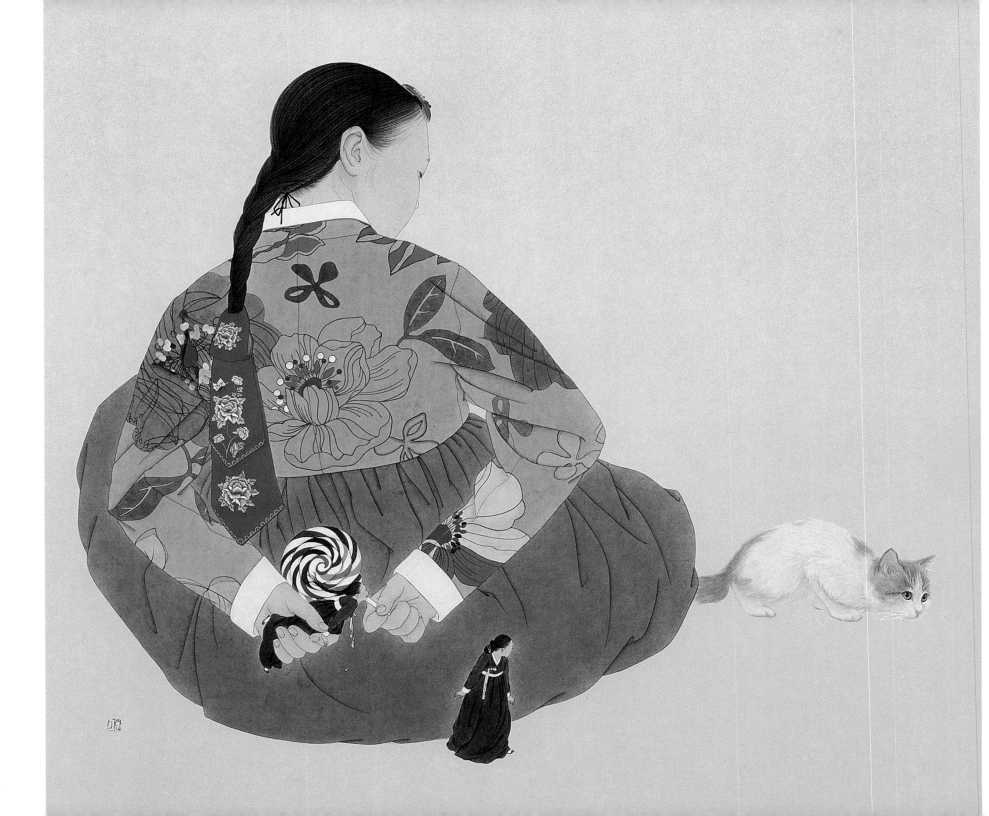

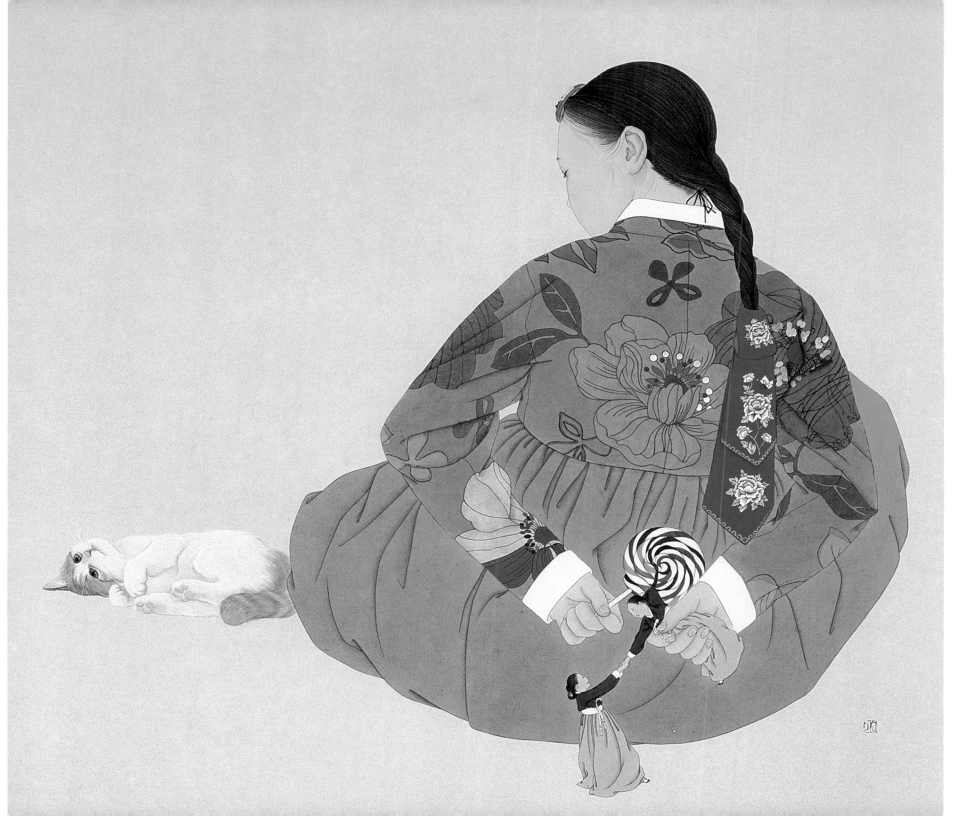

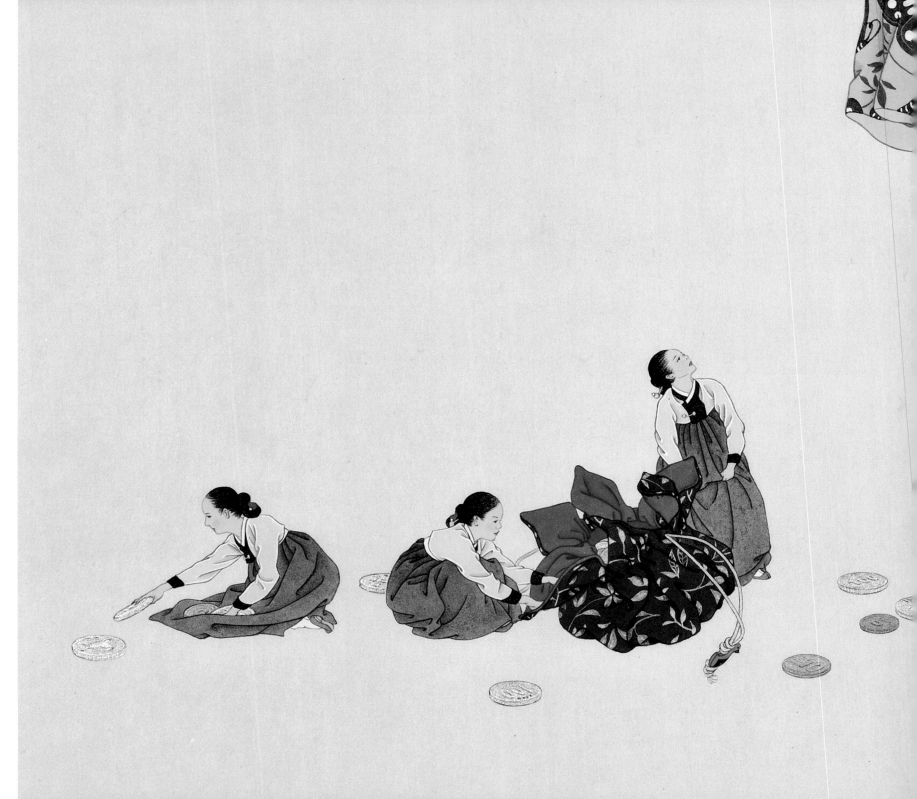

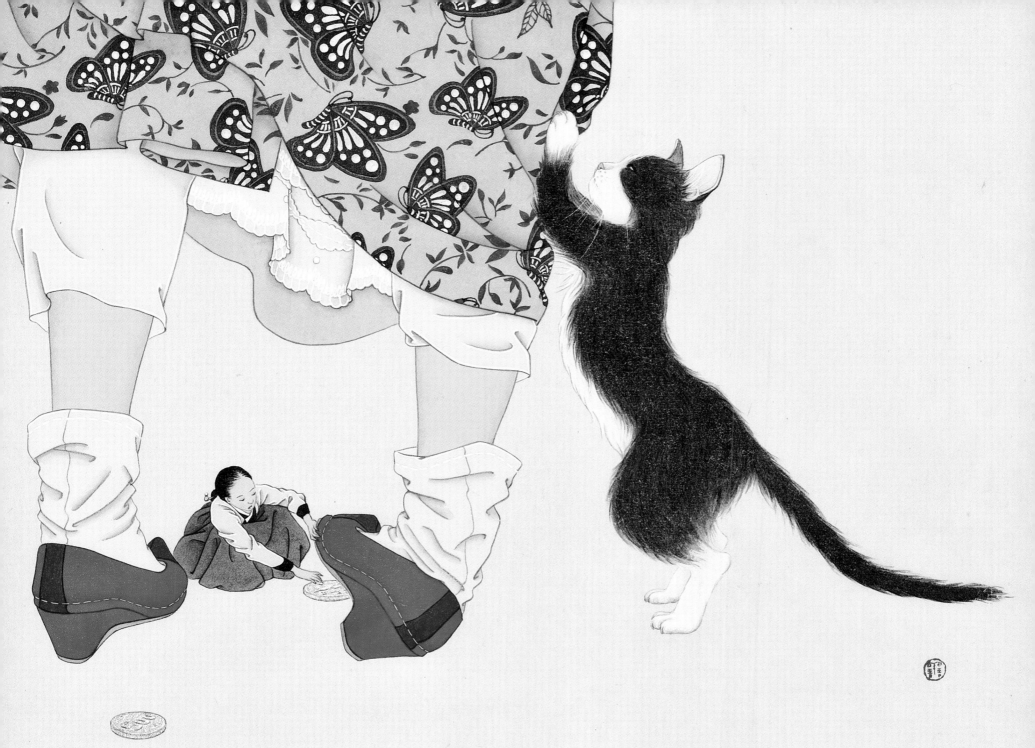

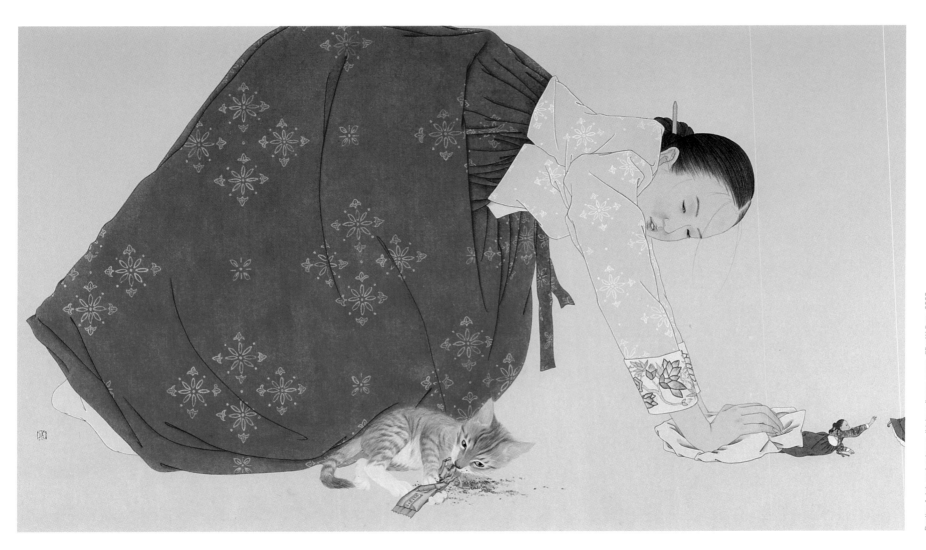

Destiny 1, Ink and color on thick mulberry paper, 65×111.5cm, 2008,

팔자 1 65×111.5 장지에 채색 2008

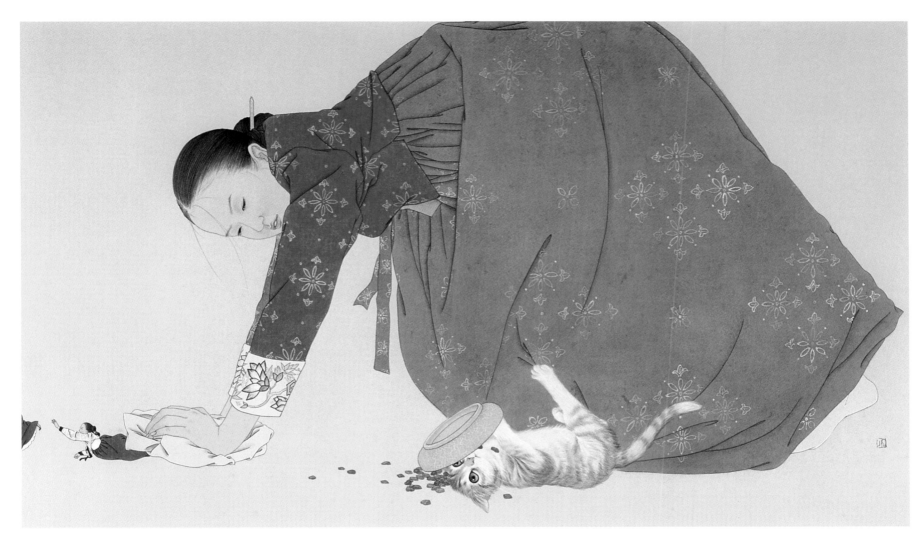

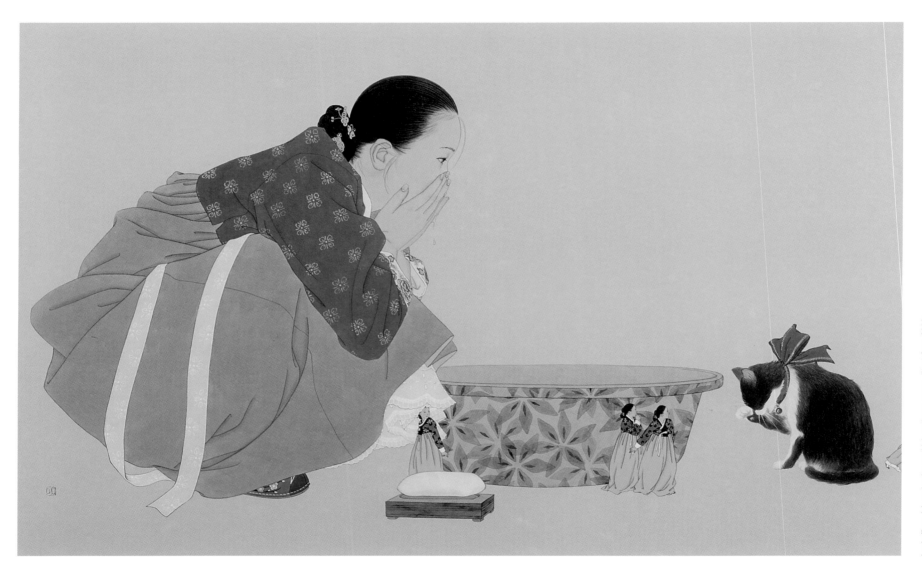

Lookalikes, Ink and color on thick mulberry paper, 71×116cm, 2009.

닮은꼴 71×116 장지에 채색 2009

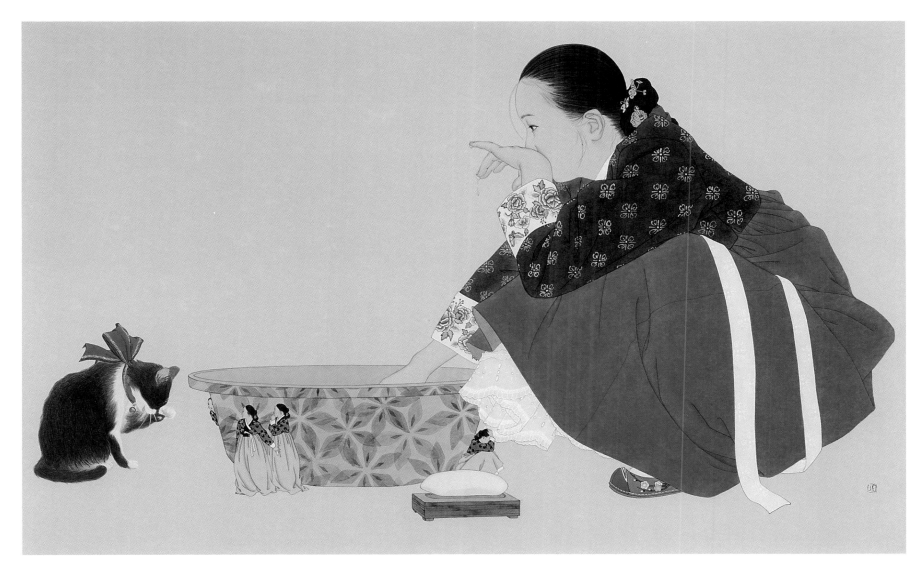

닮은꼴 2 71×116 장지에 채석 2009

Lookalikes 2. Ink and color on thick mulberry paper, 71×116cm, 2009.

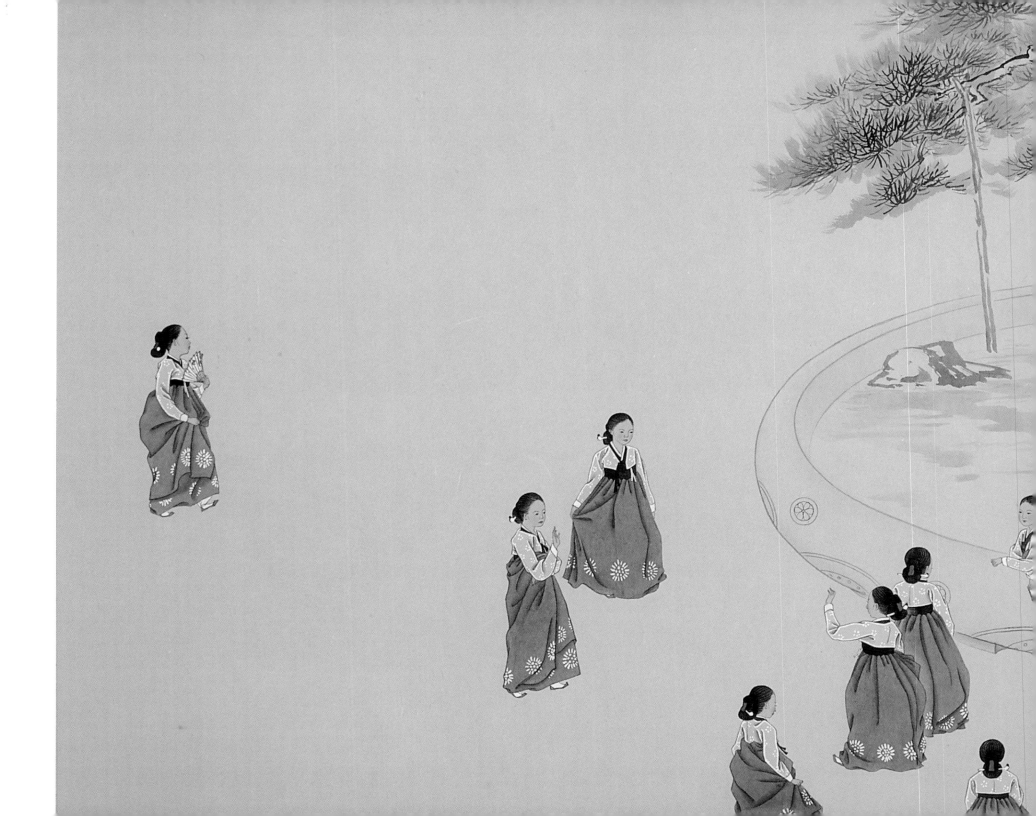

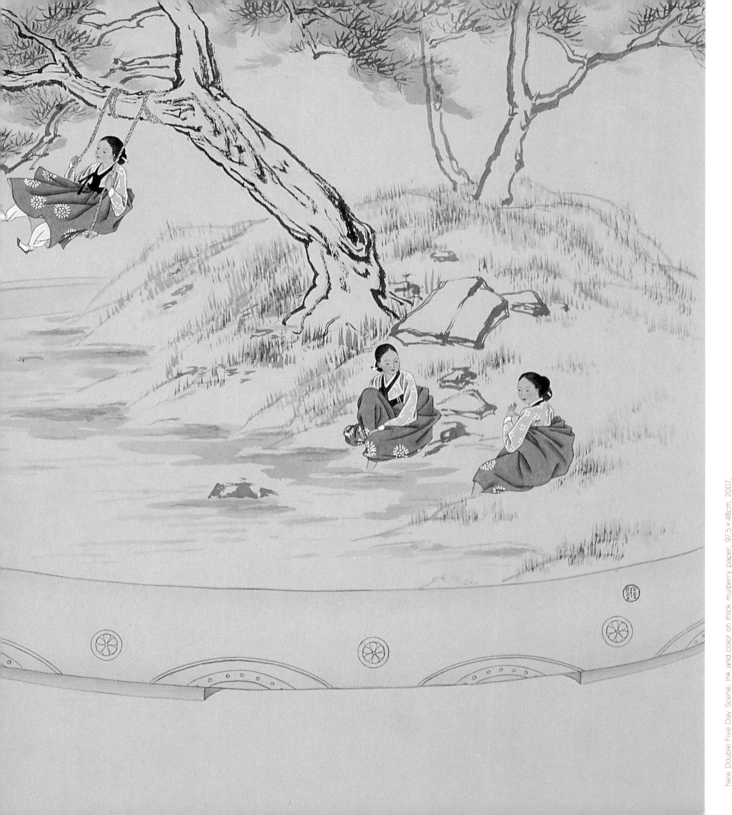

New Double Five Day Scene, Ink and color on thick mulberry paper, 97.5 × 48cm, 2007.

新端午風情 97.5 × 48 장지에 채색 2007

Dreamlike Encounter

"Could I meet them again if I fall asleep?"
The ant fairies would come when I was half asleep.
I have never seen them after I became an adult.
"Could I recognize them if I meet them again?"
Maybe they have always been around near me.
Probably it was me who has changed.
I didn't realize they were around.
Because I fell asleep with my eyes closed.

2. While You are Asleep
당신이 잠든 사이

꿈결처럼 만났던 그들

'잠이 들면 다시 만날 수 있을까?'
항상 잠결에 꿈처럼 다가왔던 개미요정들.
어른이 된 후 한 번도 보지 못한 그들.
'다시 만나면 알아볼 수 있을까?'
어쩌면 그들은 늘 그렇듯 가까이 있는지도 모른다.
변한 건 나였을지도.
그들이 곁에 있어도 알아차리지 못했다.
눈을 감고 잠들어버렸으니까.

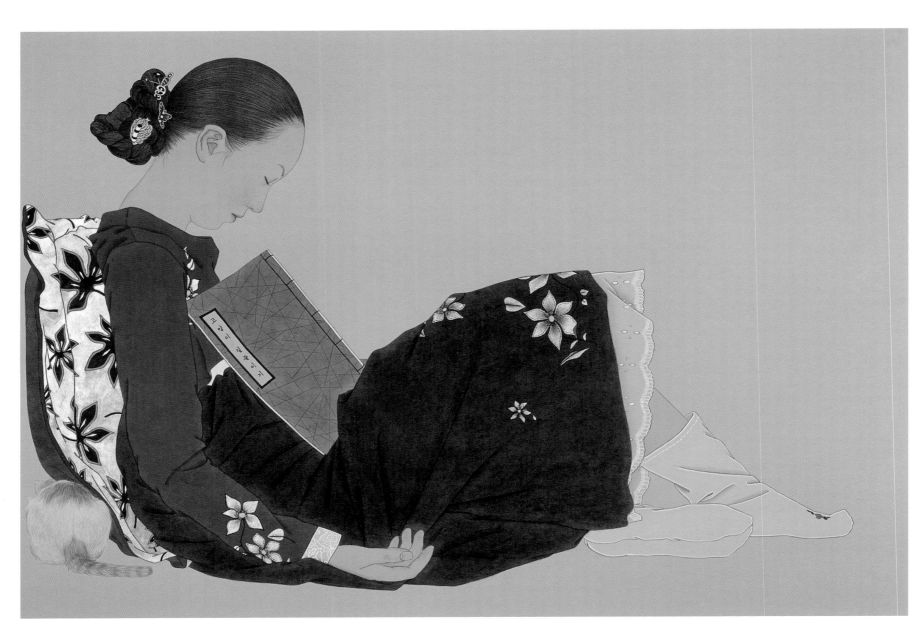

While You are Asleep 2-1, Ink and color on thick mulberry paper, 62×92.5cm, 2007,

당신이 잠든 사이 2-1 62×92.5 장지에 채색 2007

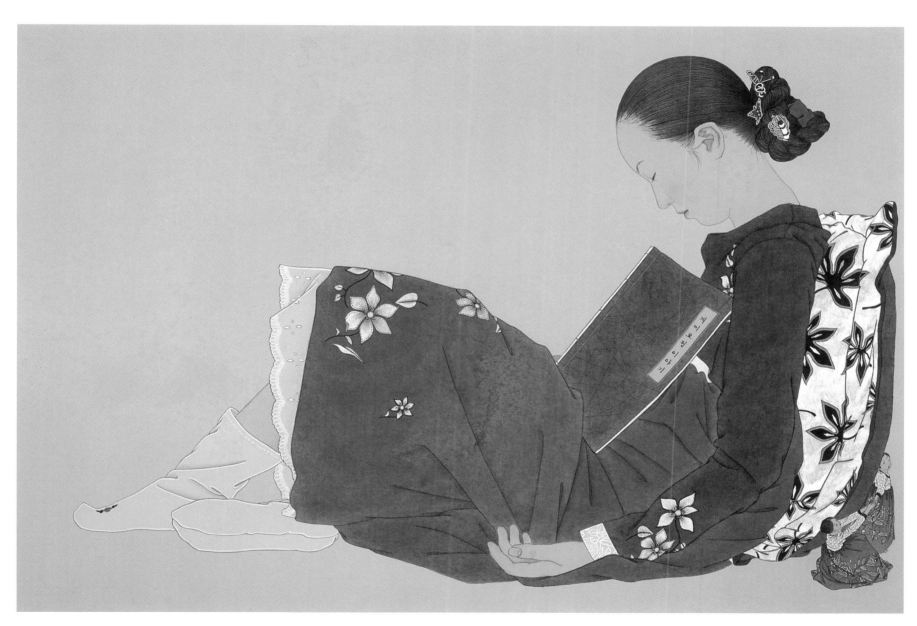

While You are Asleep 2-2, Ink and color on thick mulberry paper, 62×92.5cm, 2007,

당신이 잠든 사이 2-2 62×92.5 장지에 채색 2007

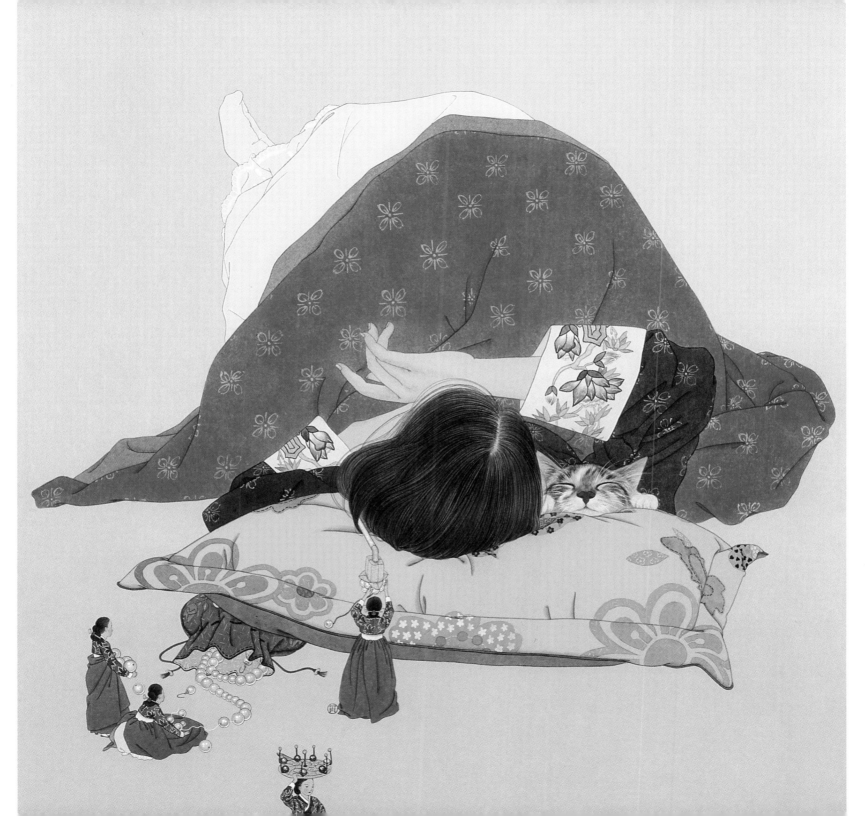

While You are Asleep 6, Ink and color on thick mulberry paper, 80×78cm, 2008.
당신이 잠든 사이 6, 80×78 장지에 채색 2008

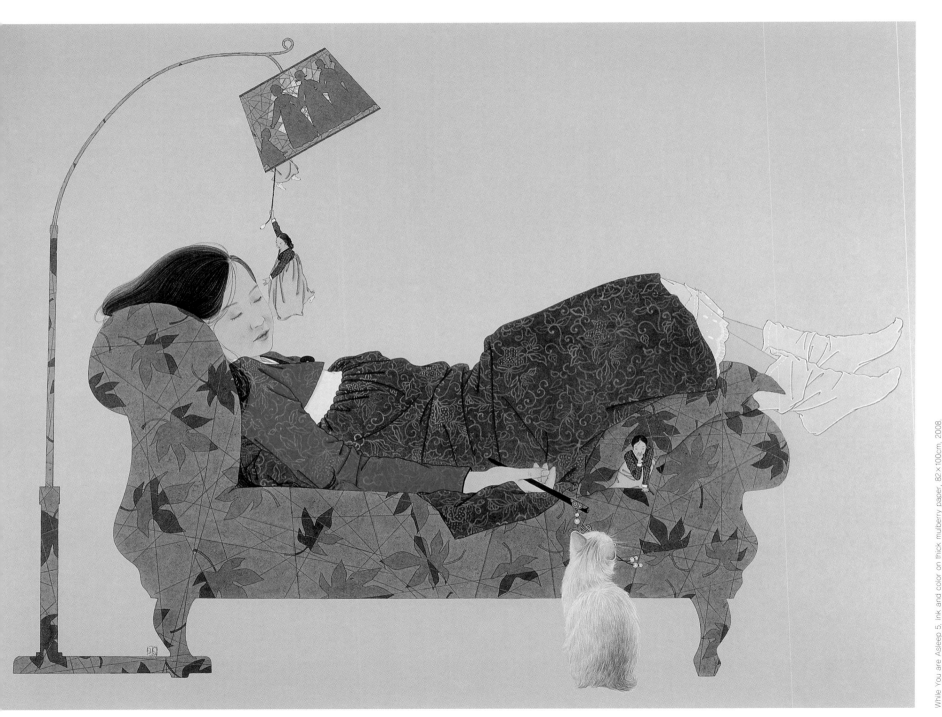

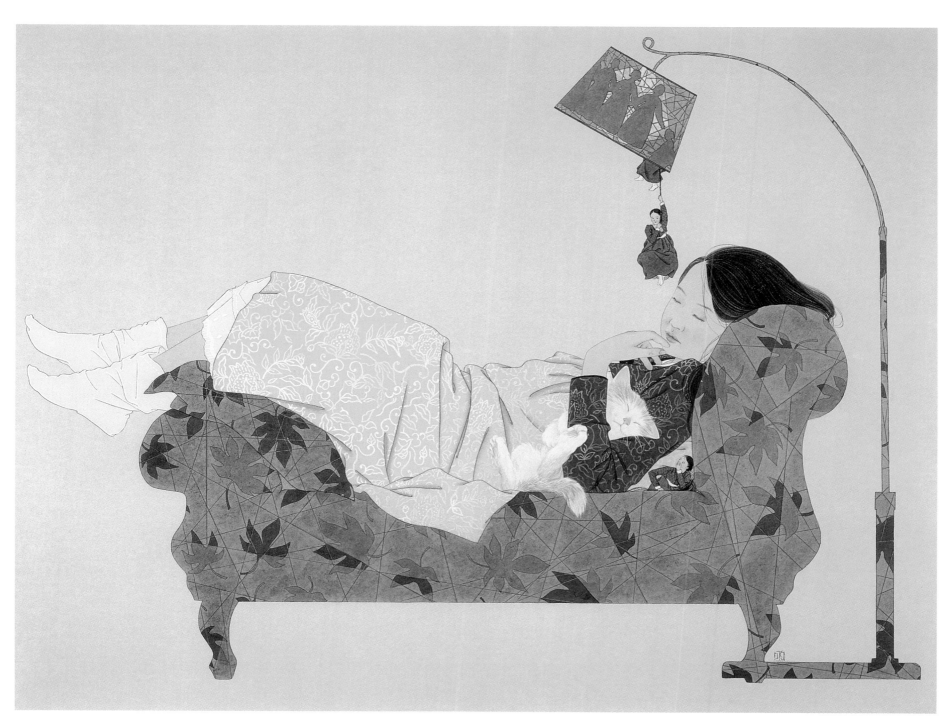

While You are Asleep 5-2, Ink and color on thick mulberry paper, 82×100cm, 2008.
당신이 잠든 사이 5-2 82×100 장지에 채색 2008

While You are Asleep 8, Ink and color on thick mulberry paper, 77×116cm, 2008.

당신이 잠든 사이 8 77×116 장지에 채색 2008

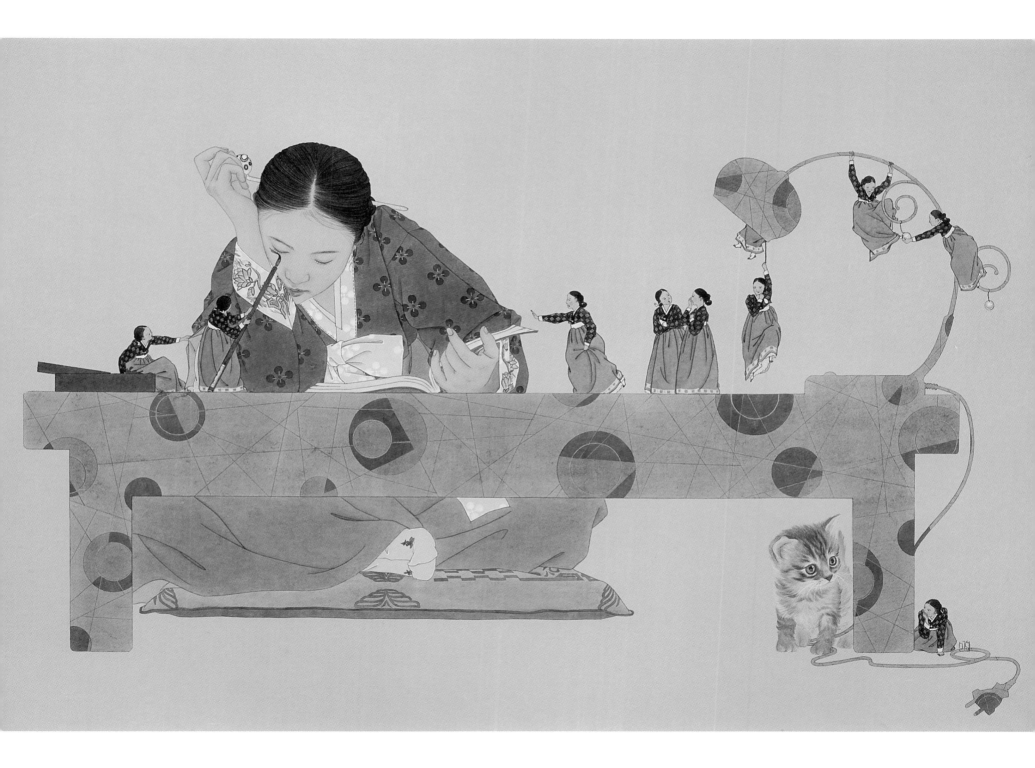

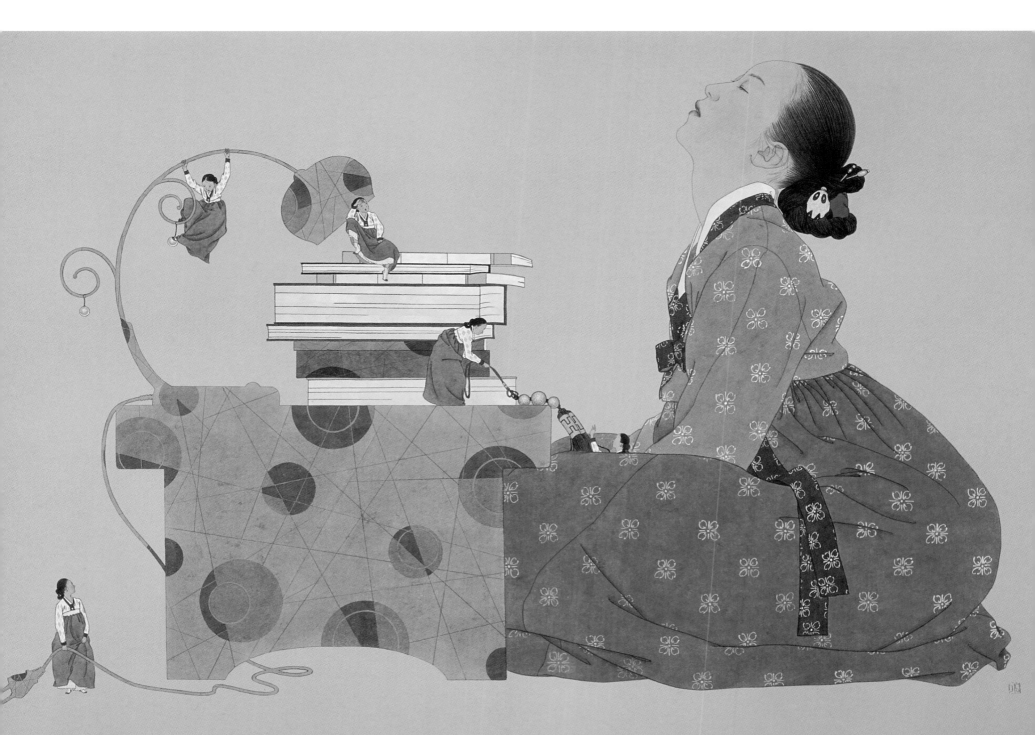

Prenatal Education, Ink and color on thick mulberry paper, 105×141cm, 2010.

태교 105×141 장지에 채색 2010

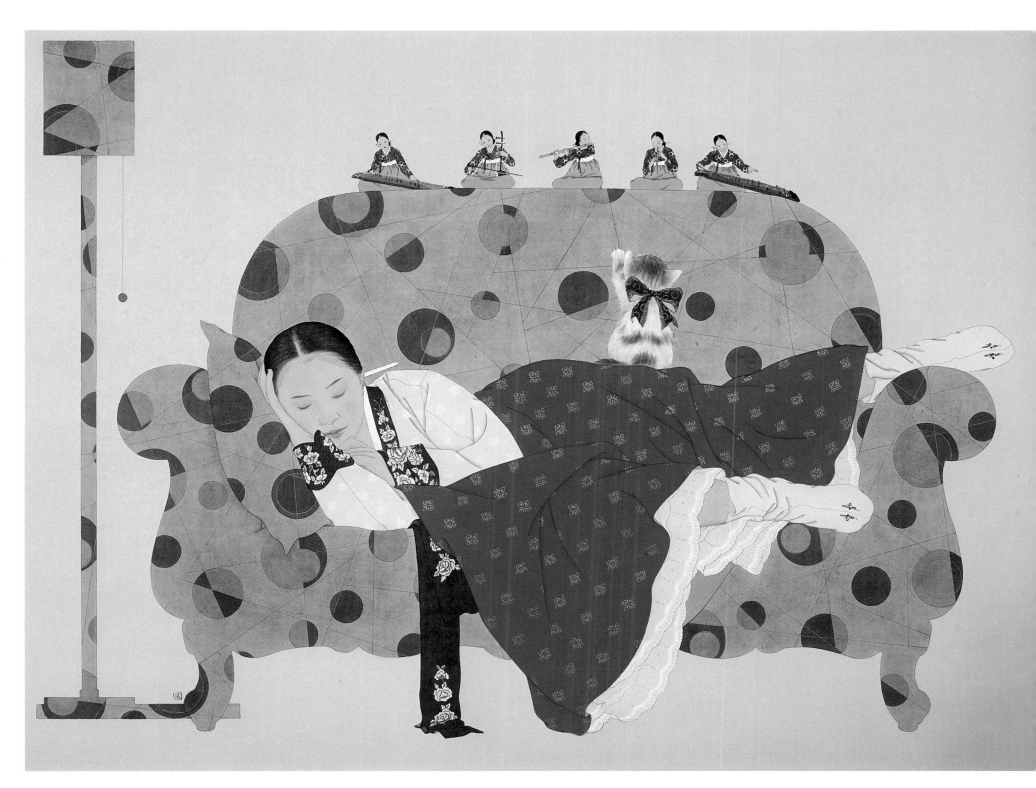

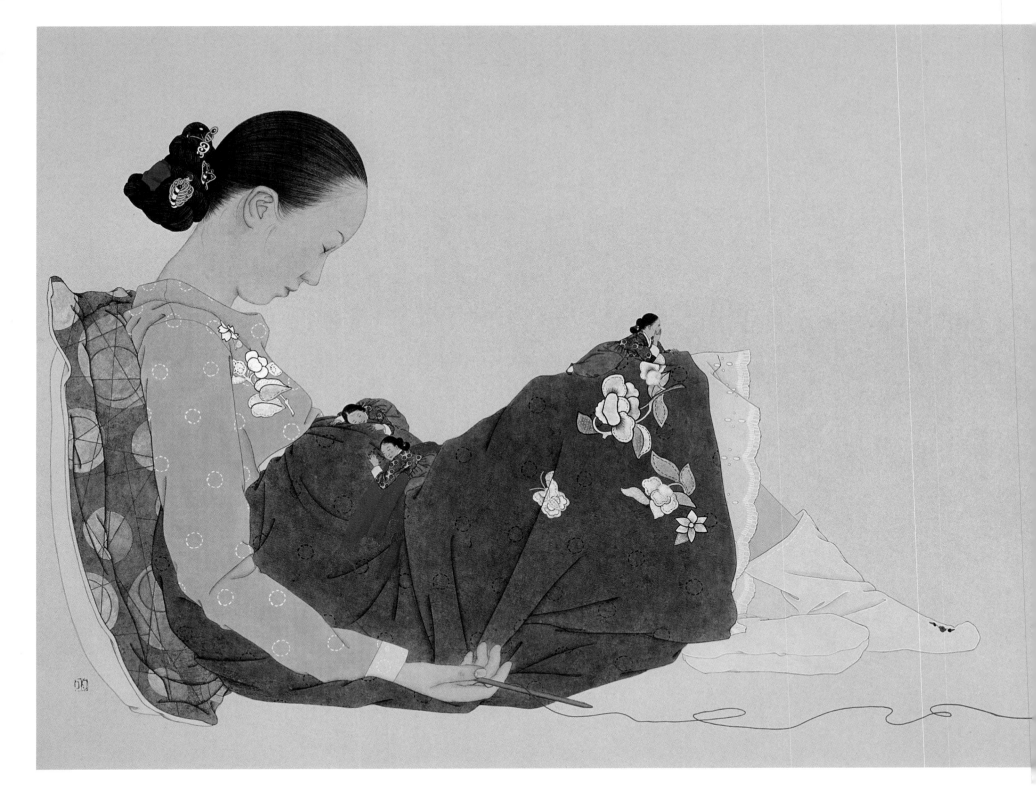

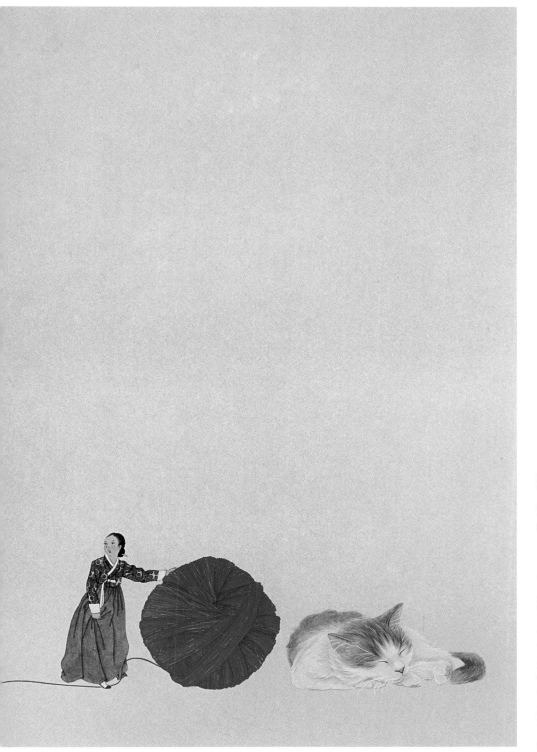

Prenatal Education 3, Ink and color on thick mulberry paper, 69×143cm, 2010,

태교 3 69×143 장지에 채색 2010

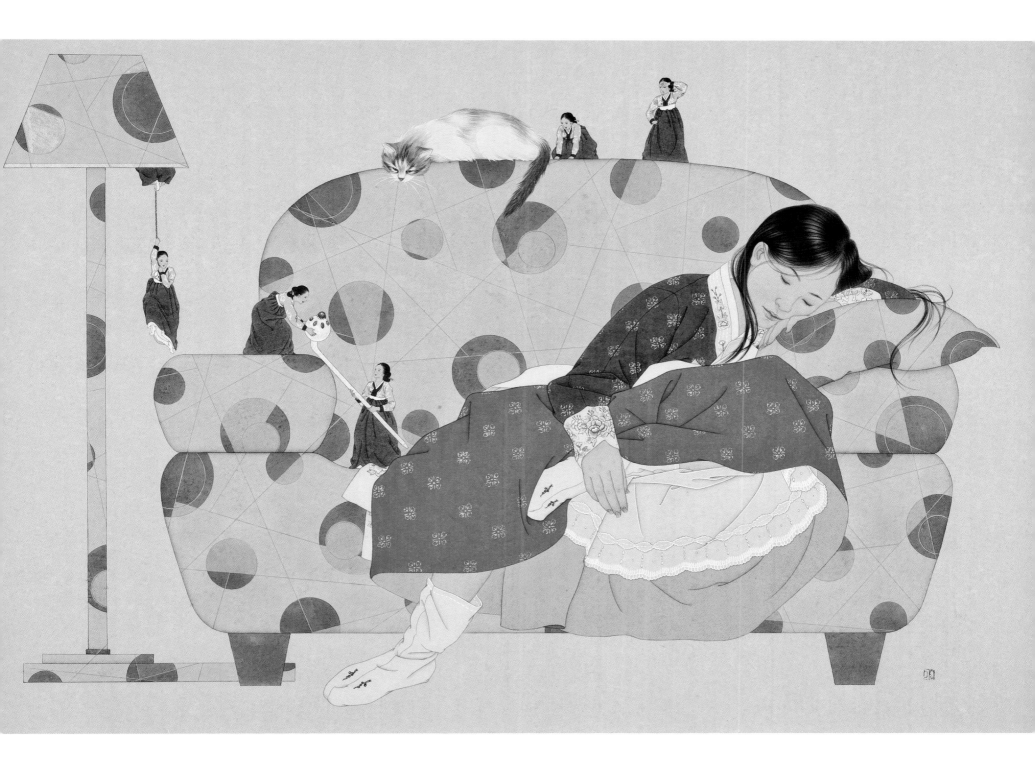

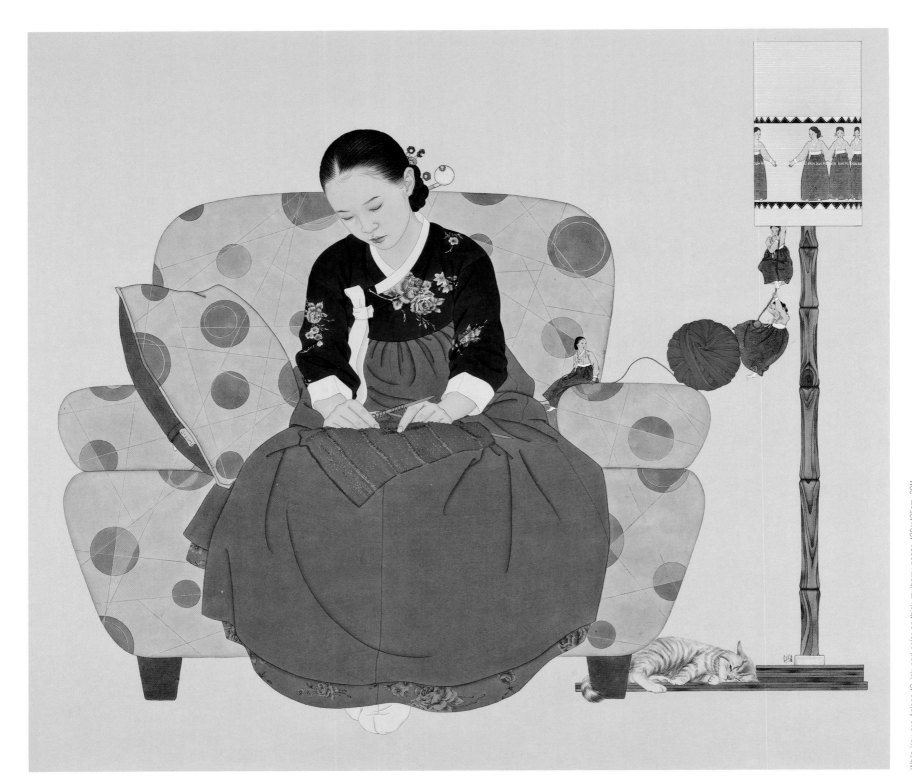

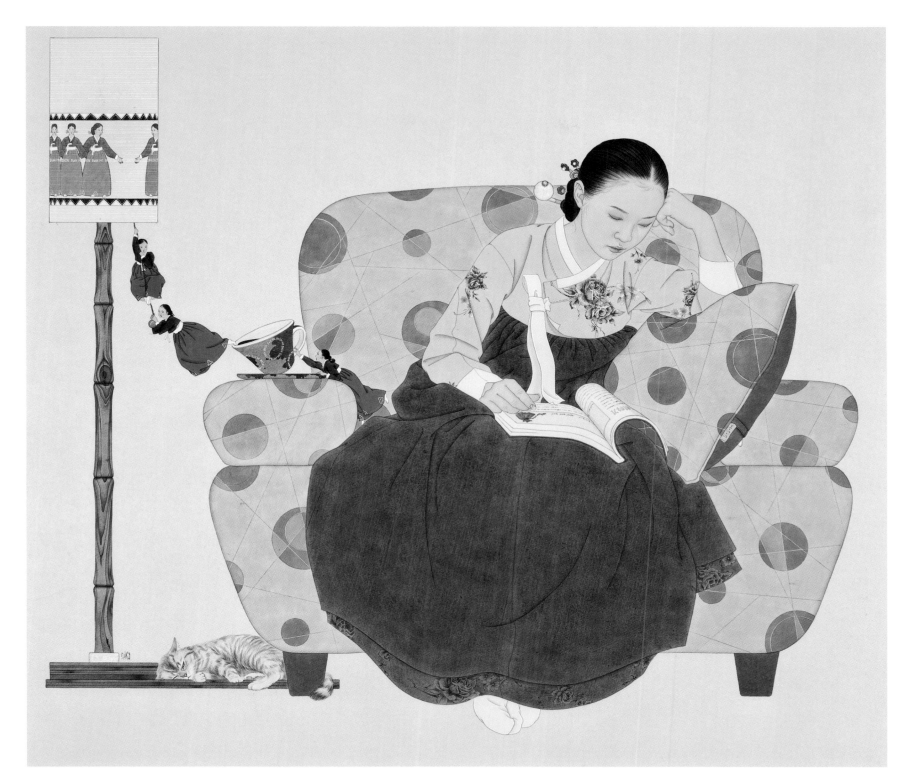

Birth of a Child, and his Growth

A new life was born.
An erstwhile plain daily routine is full of new incidents and accidents.
The ever-innocent child, once a nasty four-year-old, would so often utter
fabulously imaginative words to surprise adults.
My mom says the child reminds her of me in my childhood.
Was I like him?
I look at my child again in renewed awe.

아이의 탄생, 그리고 성장

새 생명이 태어났다.
평범했던 일상에 새로운 사건과 사고들이 생겨난다.
해맑기만 하던 아이는 미운 네 살을 거치더니,
종종 상상과 허무맹랑함이 섞인 말들로 어른들의 마음을 놀라게 하기 일쑤다.
친정 엄마는 아이의 이런 모습이 어릴 적의 나와 똑같다고 한다.
내가 그랬던가?
아이의 모습을 새삼스레 바라본다.

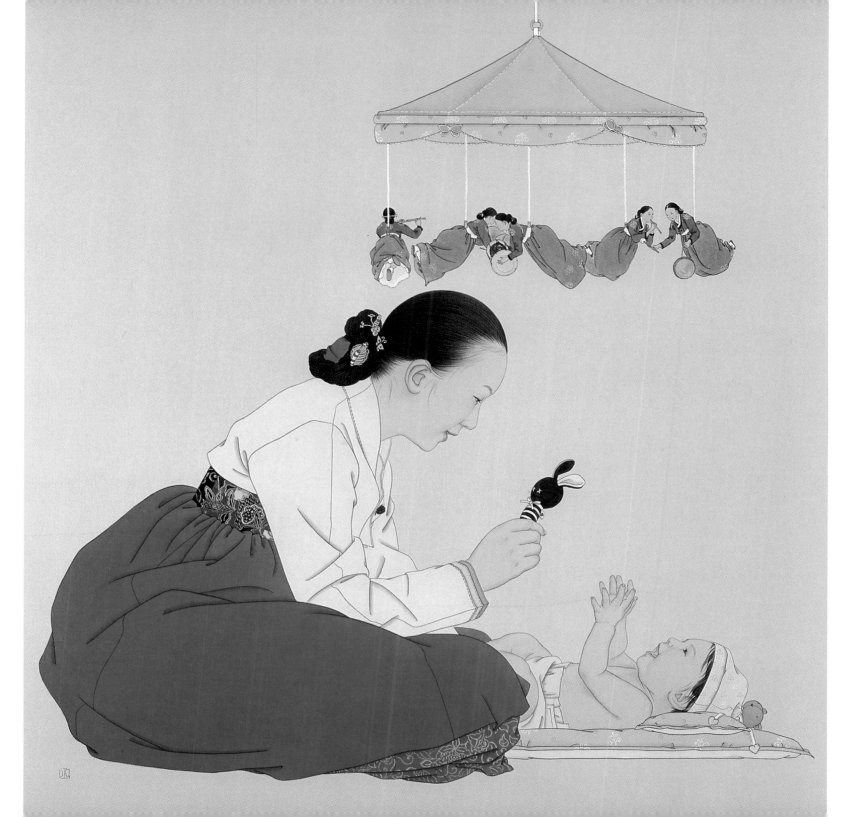

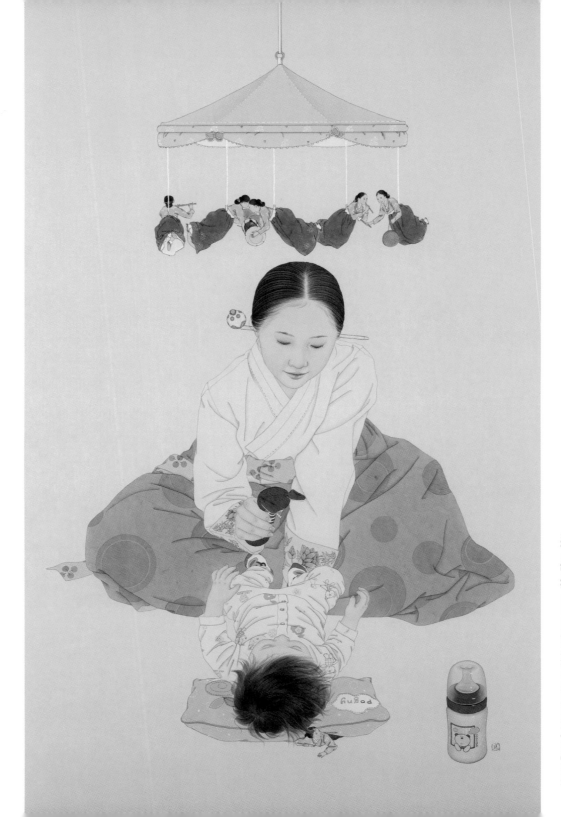

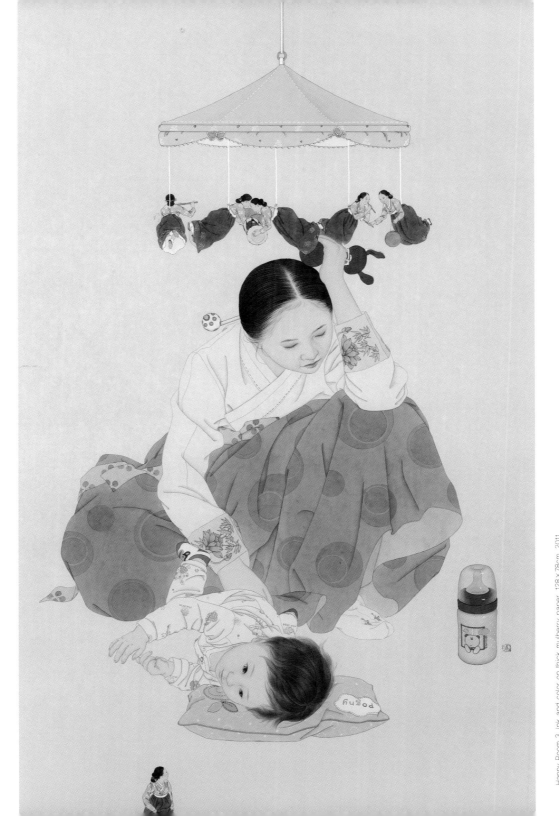

Happy Room 3, Ink and color on thick mulberry paper, 128×78cm, 2011,
행복한 방 3 128×78 장지에 채색 2011

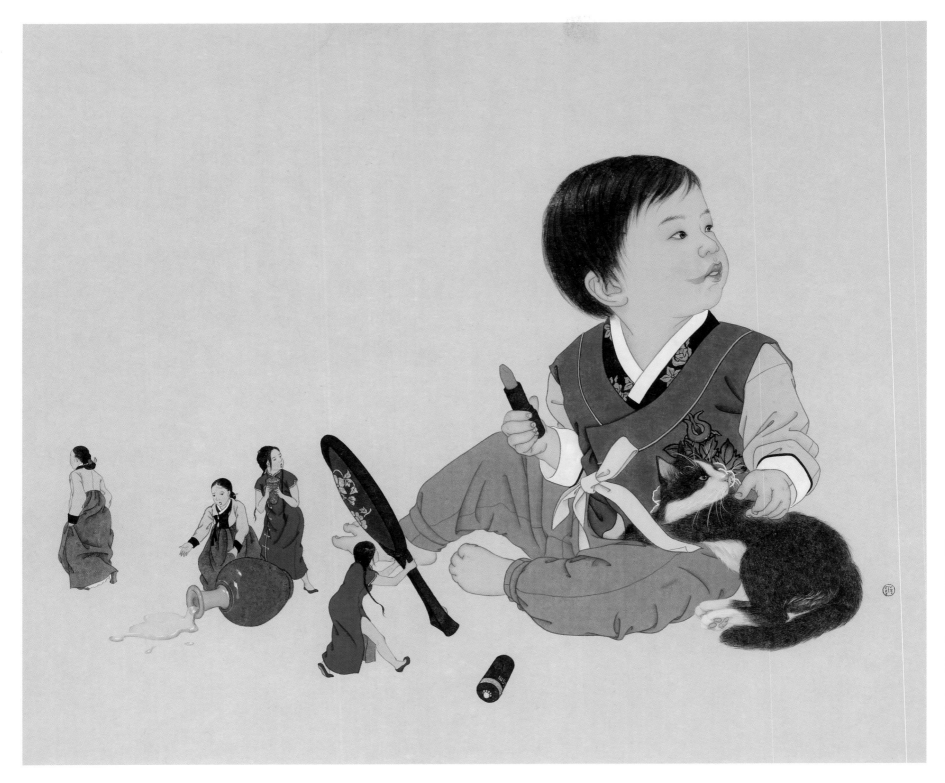

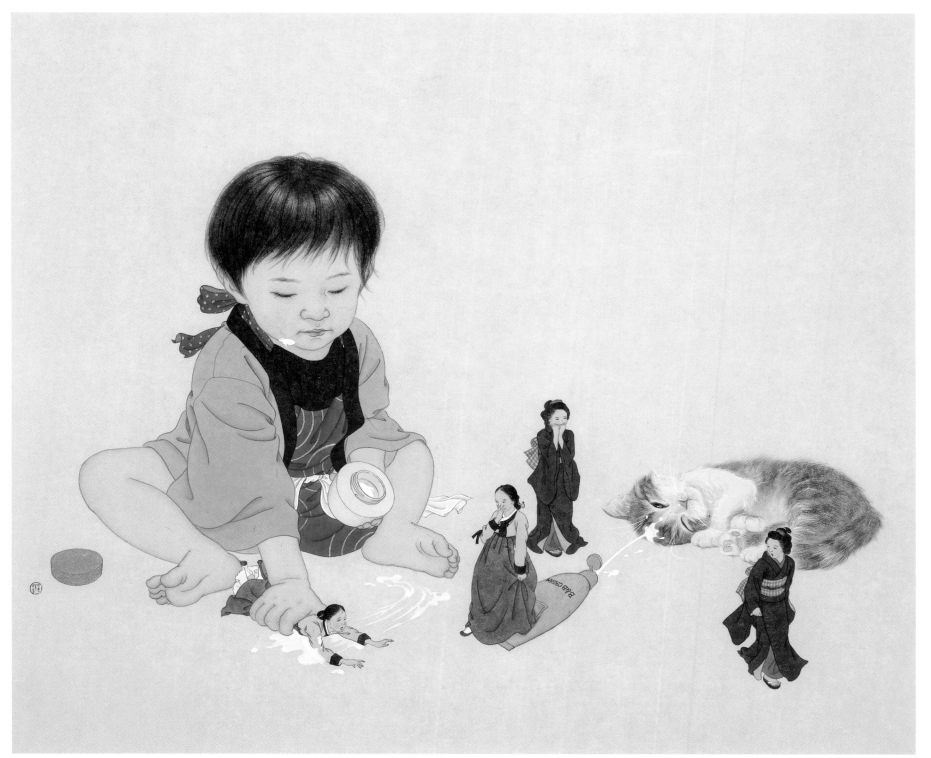

Oops 2, Ink and color on thick mulberry paper, 72×60cm, 2011,

Oops 2 72×60 장지에 채색 2011

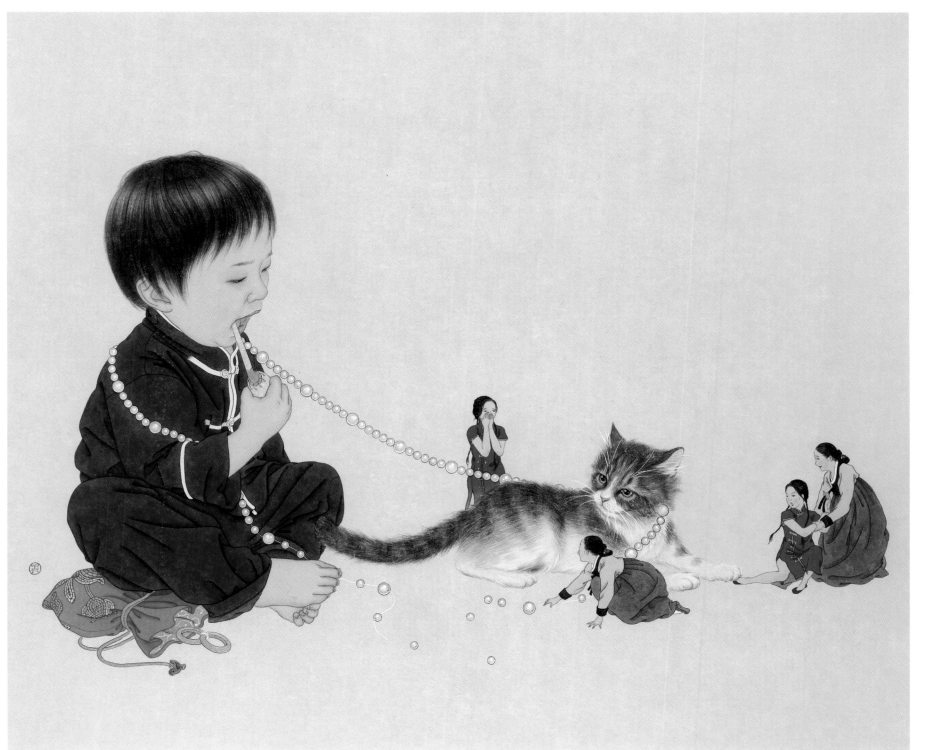

Oops. Ink and color on thick mulberry paper. 72×60cm, 2011.
Oops 72×60 장지에 채색 2011

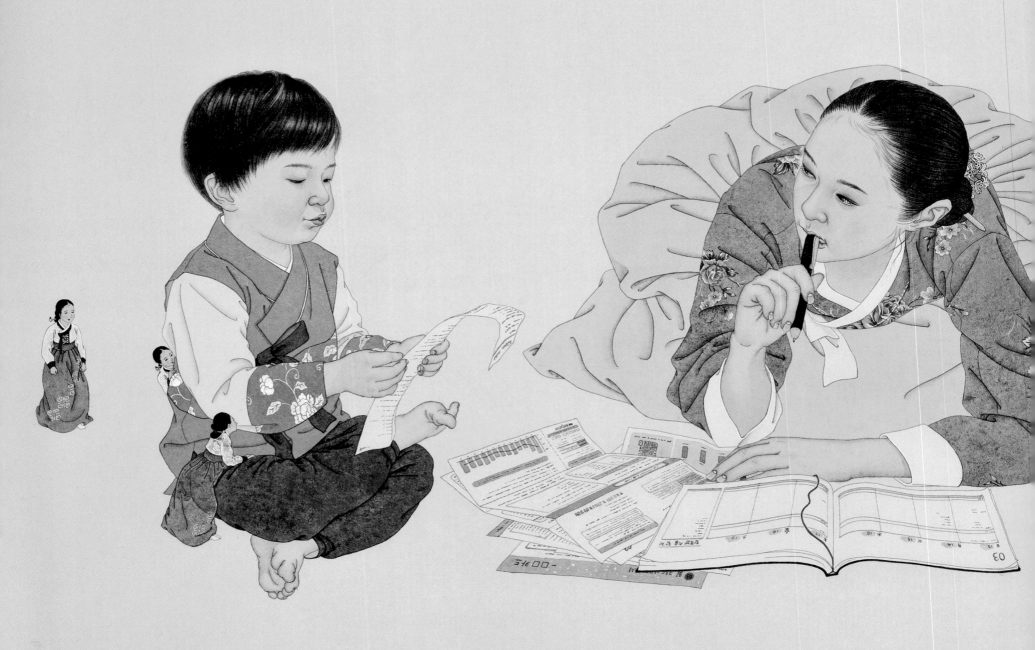

Playing Daddy 2, ink and color on thick mulberry paper, 76×119cm, 2012.
아빠놀이 2 76×119 장지에 채색 2012

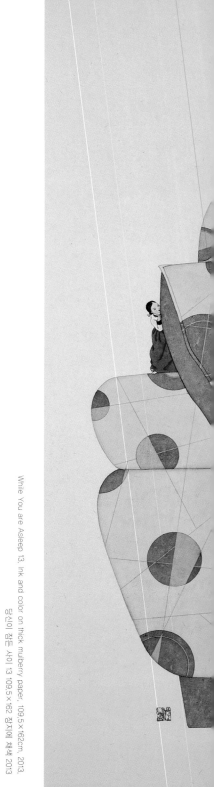

While You are Asleep 13, ink and color on thick mulberry paper, 109.5 × 162cm, 2013.
당신이 잠든 사이 13 109.5 × 162 장지에 채색 2013

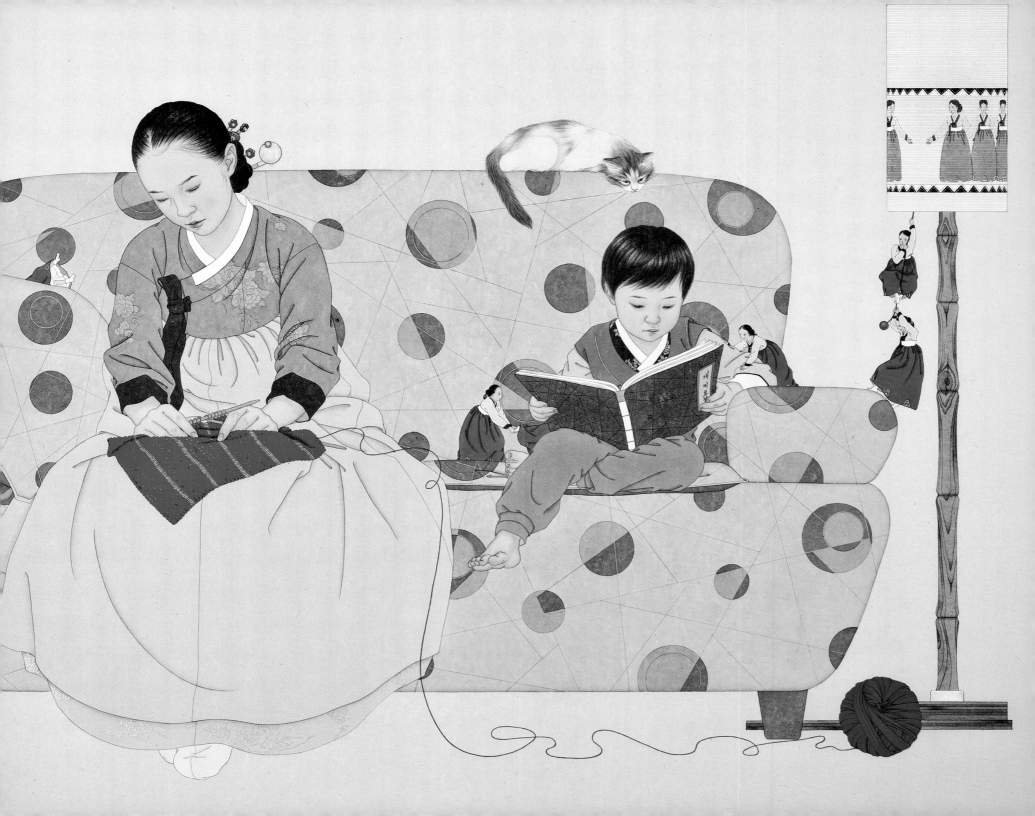

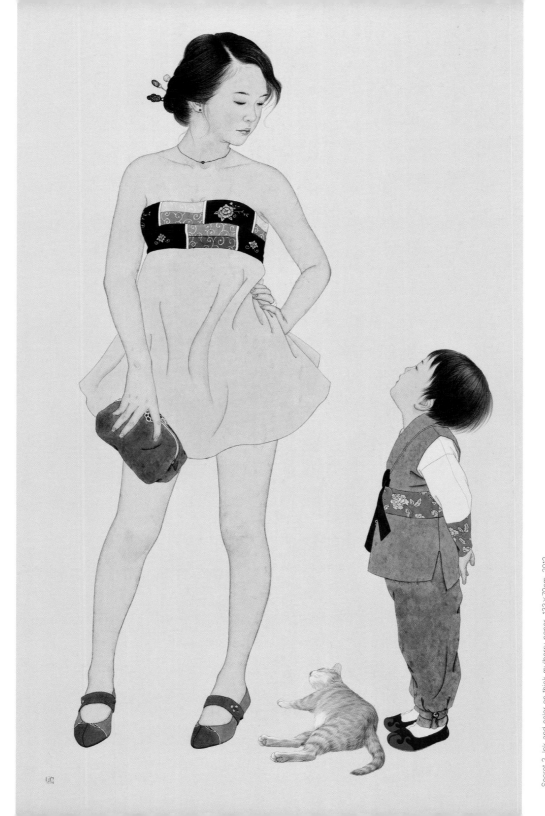

Secret 2, ink and color on thick mulberry paper, 133×79cm, 2012,
Secret 2 133×79 장지에 채색 2012

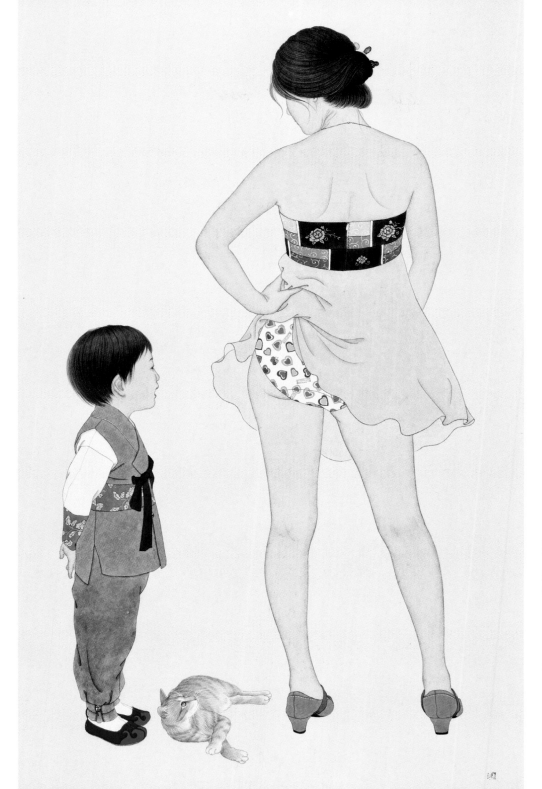

Secret 2-2, ink and color on thick mulberry paper, 133 x 79cm, 2012,
Secret 2-2 133×79 장지에 채색 2012

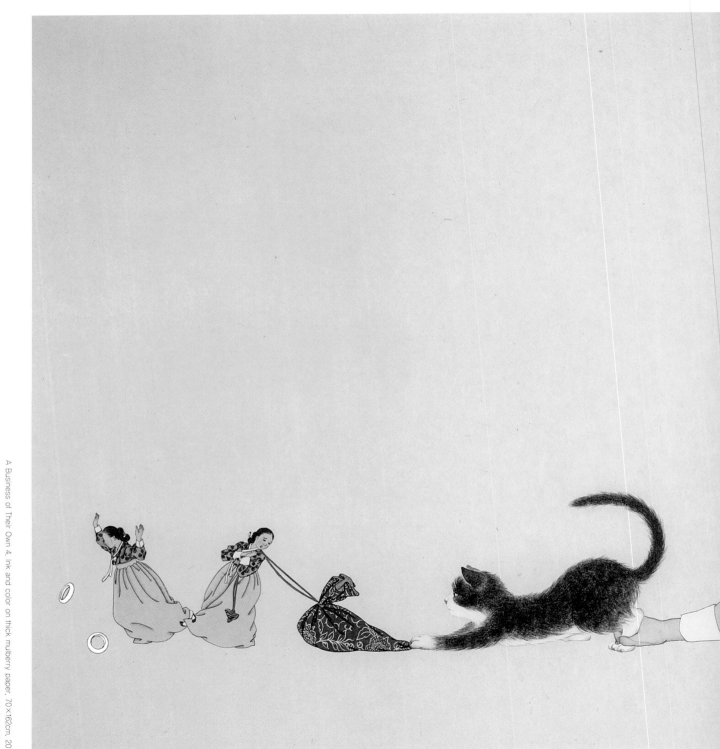

A Business of Their Own 4, ink and color on thick mulberry paper, 70×162cm, 2012.
그들만의 사정 4 70×162 장지에 채색 2012

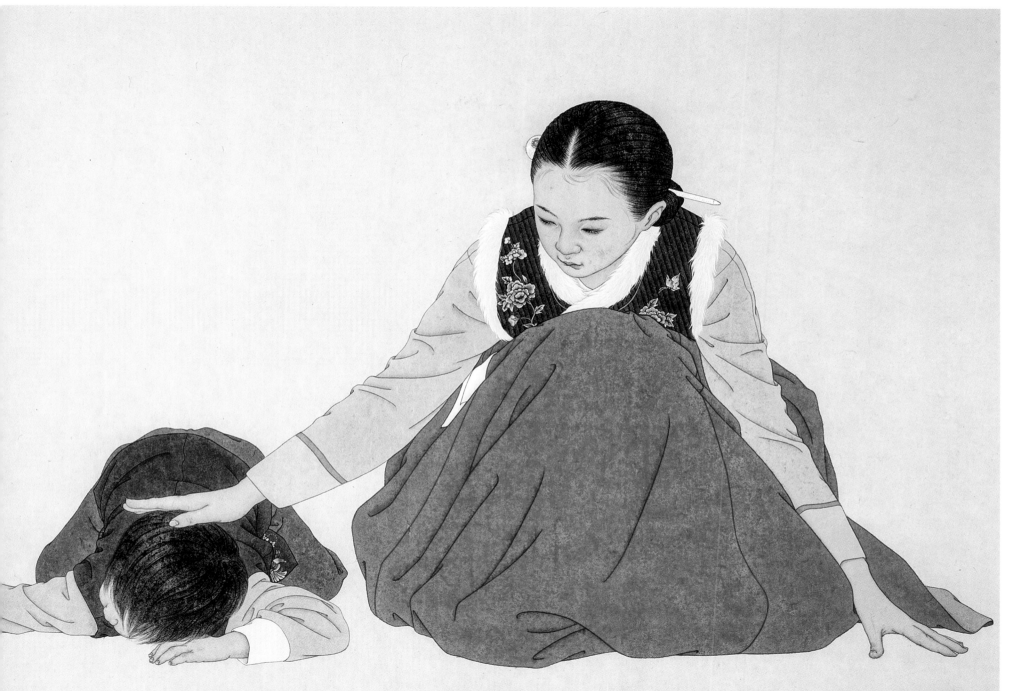

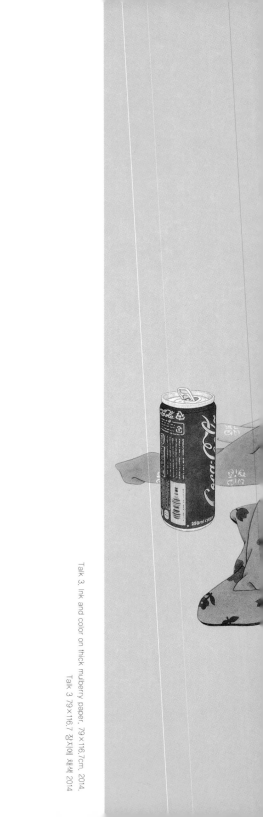

Talk 3, ink and color on thick mulberry paper, 79×116.7cm, 2014.
Talk 3 79×116.7 장지에 채색 2014

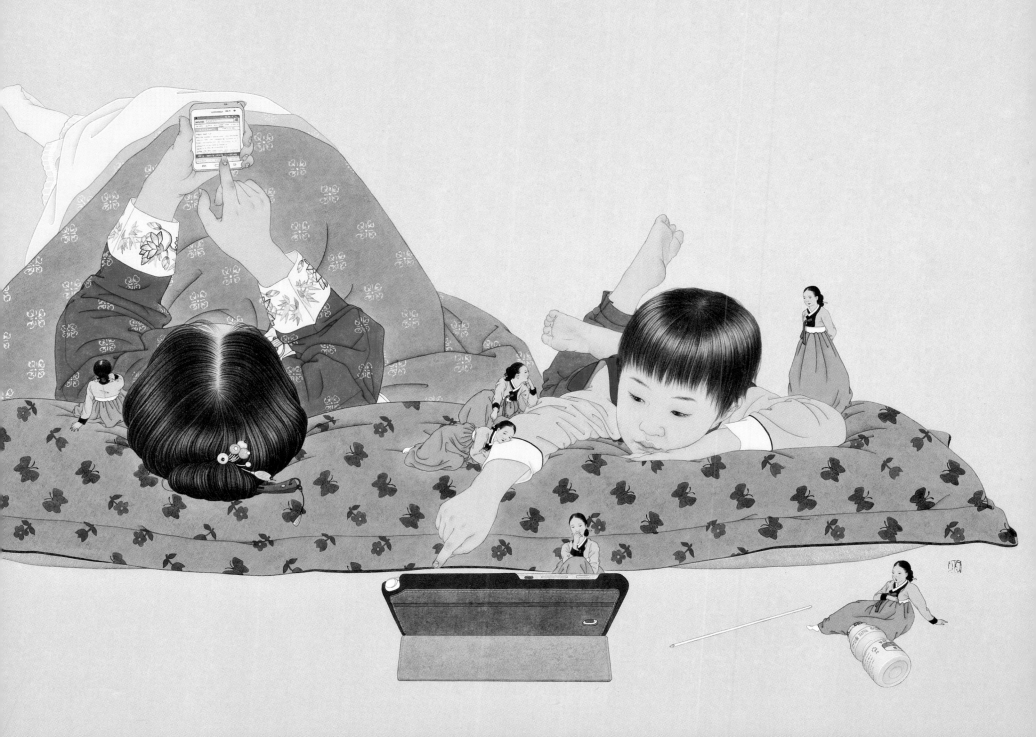

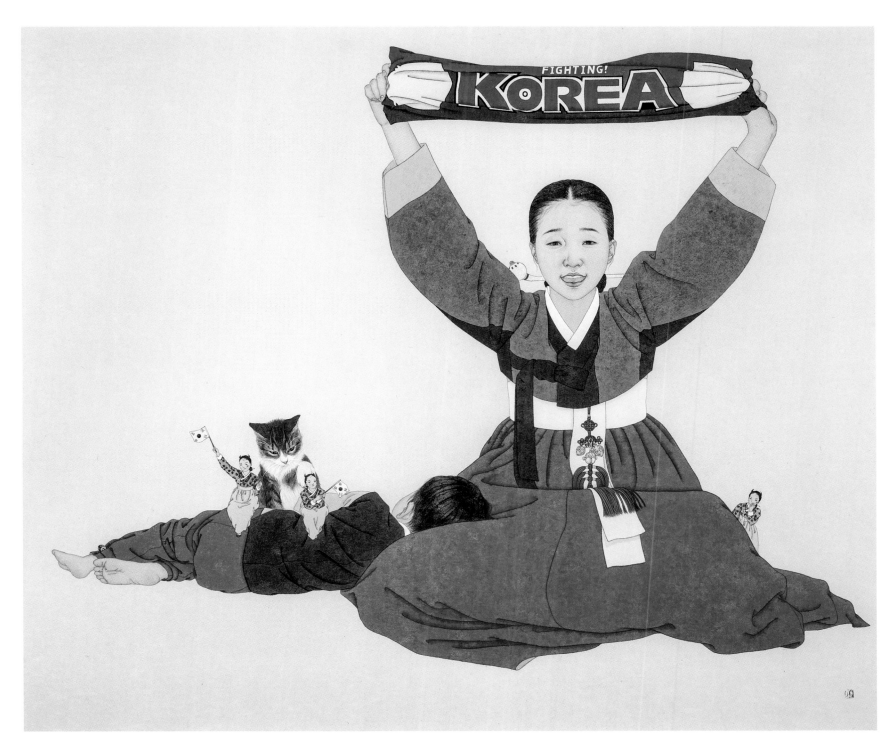

Dae-han-min-guk! (Korea! Korea!). Ink and color on thick mulberry paper. 100×120cm. 2012.
대한민국! 100×120 장지에 채색 2012

Let's Meet Again

Watching my child sulk after a scolding for misbehavior
Brings back memories from my own younger days.
Adults would scold me when I told them about the ant fairies,
Then I would grow sulky, and keep all my stories to myself.
Didn't my child have reasons that only he knows for causing trouble?
Looking at my child blankly, I meet again
Myself of my childhood — and them.

우리, 다시 만나자

말썽 부린 아이를 혼내다 아이의 토라진 모습을 보고,
문득 잊고 있던 내 어린 시절이 떠올랐다.
개미요정 이야기를 들려주면 어른들은 이상한 소리라며 꾸짖었고,
그러면 토라져 속상함을 혼자 마음속에 묻어두곤 했던 어린 나.
아이가 말썽을 부릴 때는 아이만 알고 있는 마땅한 이유가 있었던 건 아닐까?
아이를 물끄러미 바라보다, 다시 만나게 된다.
어린 시절의 나와 그들을.

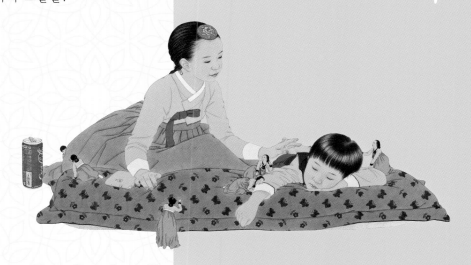

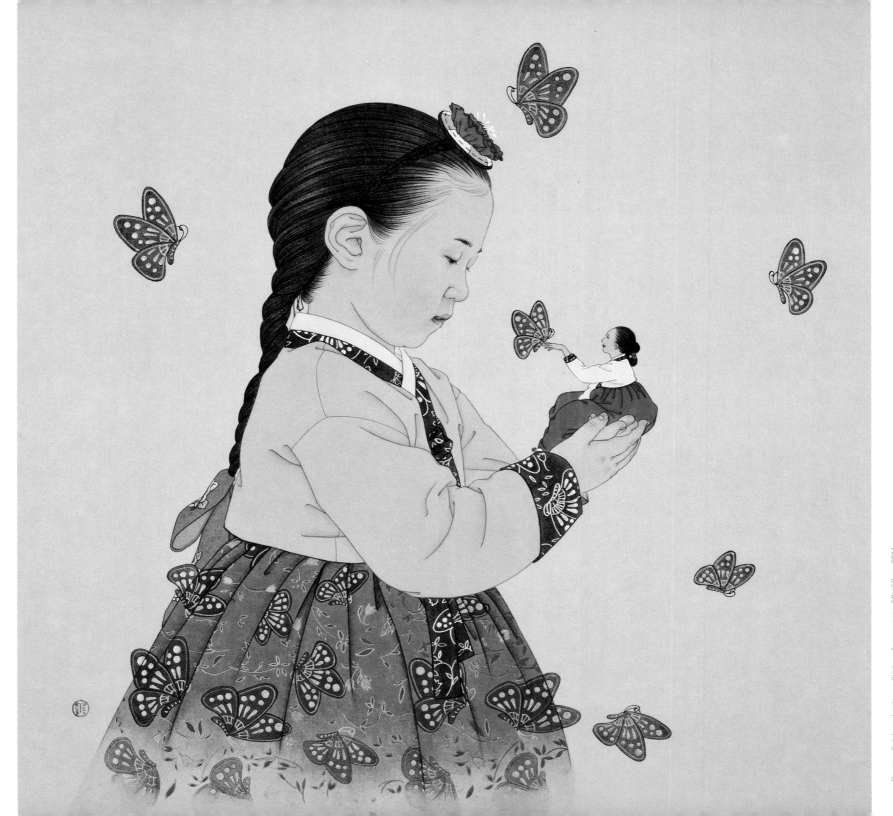

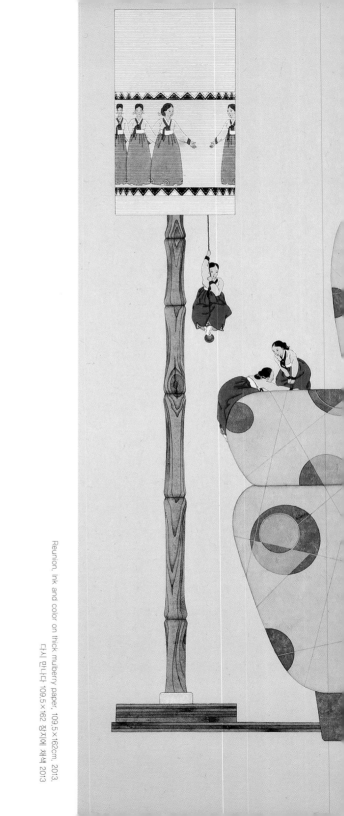

Reunion, Ink and color on thick mulberry paper, 109.5×162cm, 2013.
다시 만나다 109.5×162 장지에 채색 2013

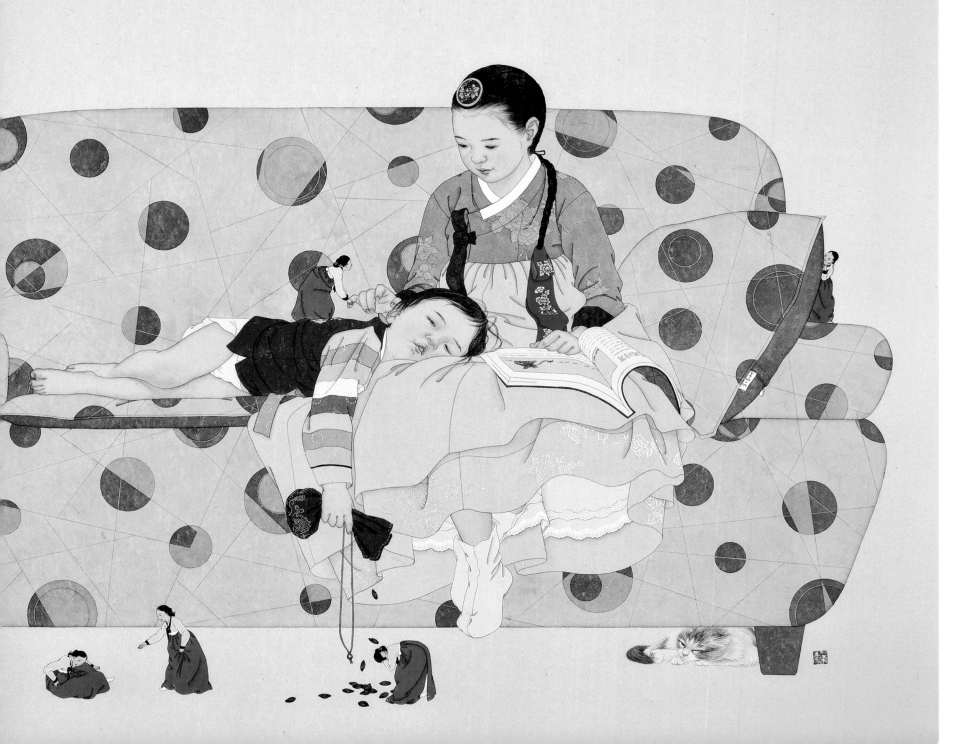

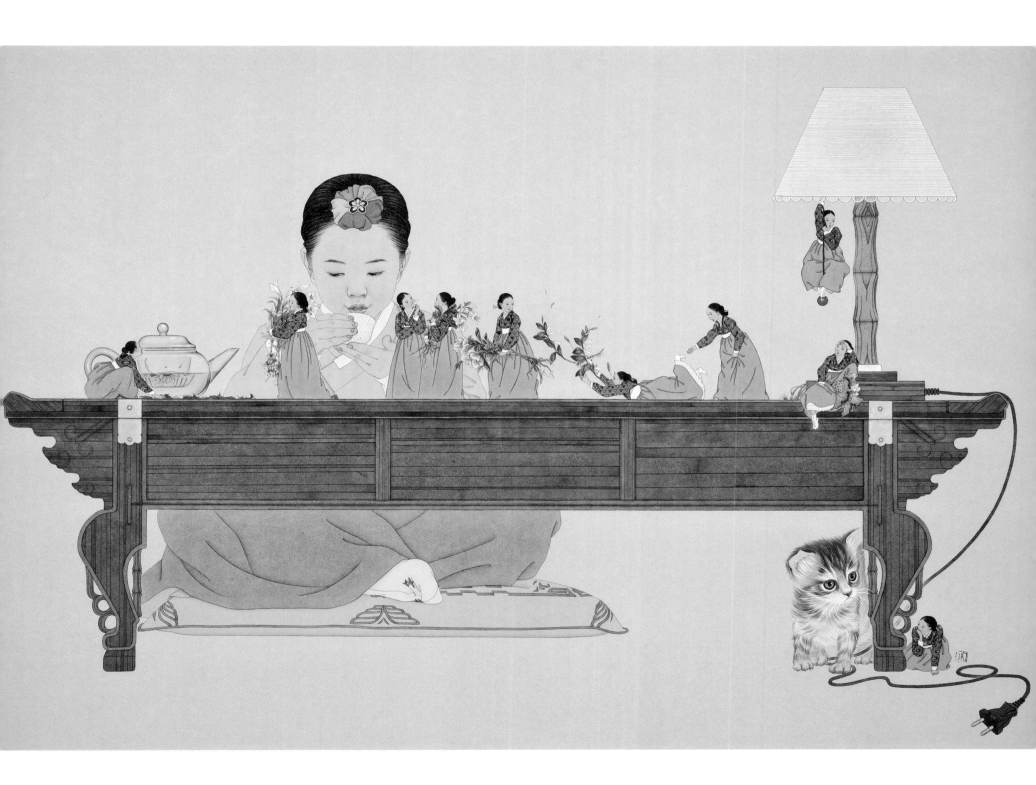

Reunion 6, Ink and color on thick mulberry paper, 79×116.7cm, 2014,

다시 만나다 6 79×116.7 장지에 채색 2014

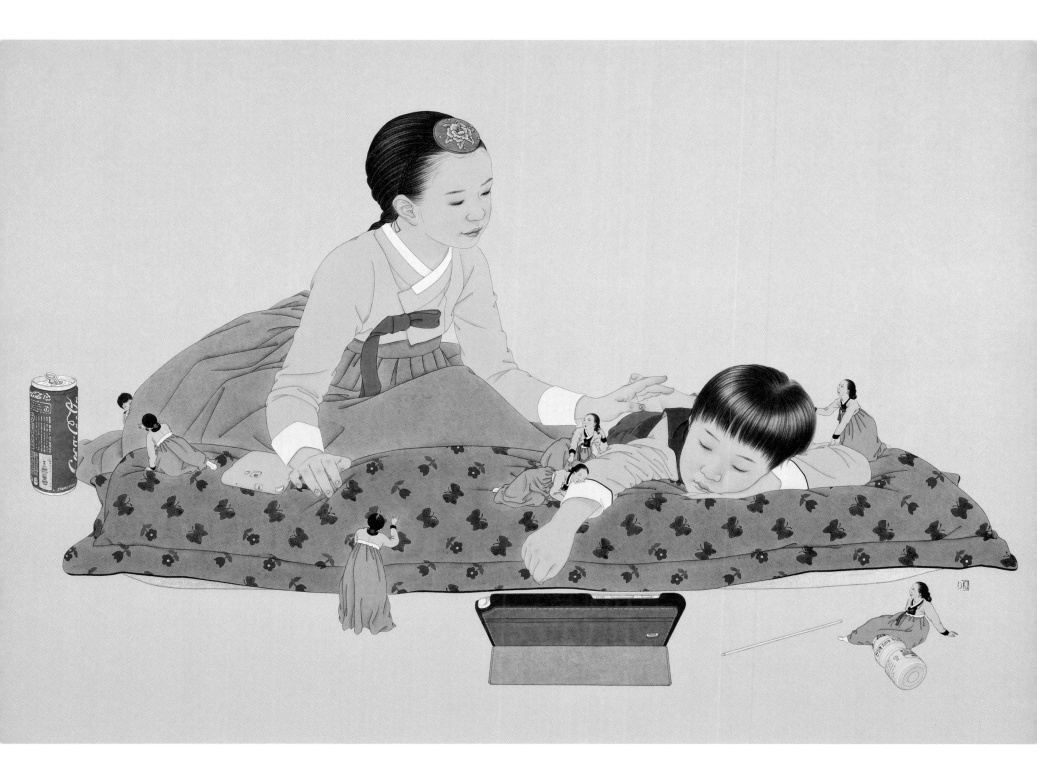

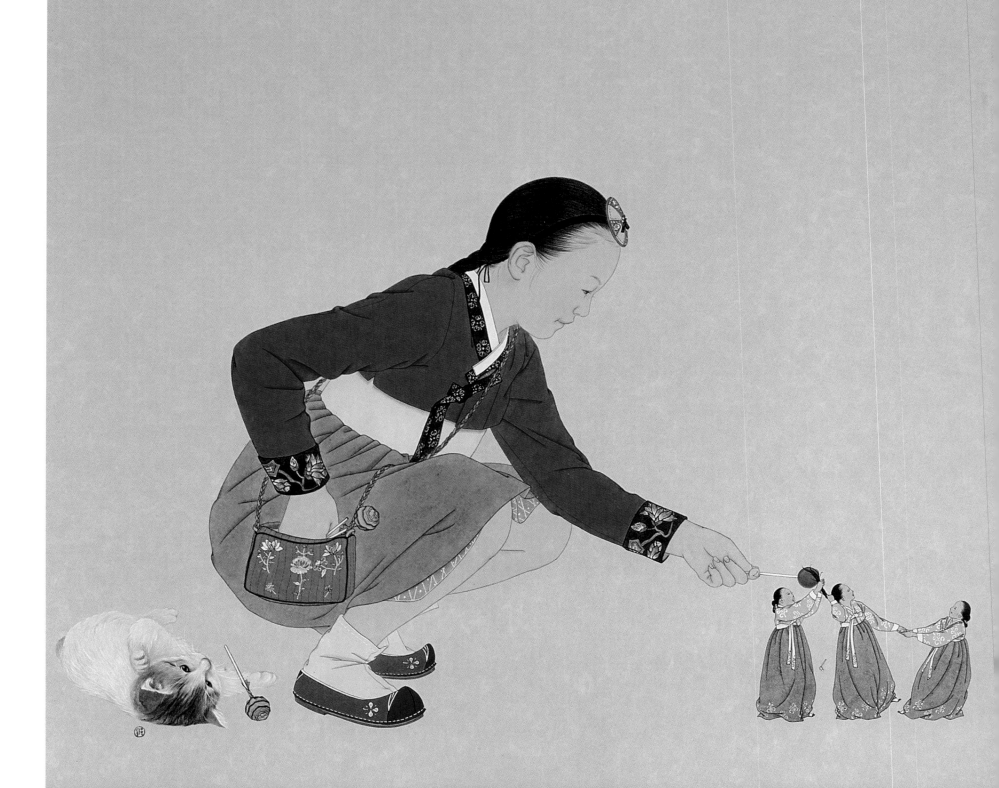

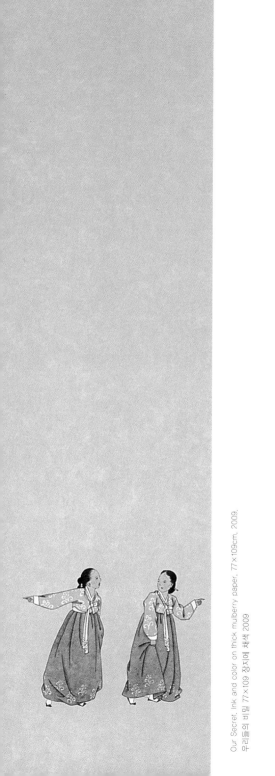

Our Secret. Ink and color on thick mulberry paper. 77×109cm, 2009.
우리들의 비밀 77×109 장지에 채색 2009

Our Secret 2, Ink and color on thick mulberry paper, 77×109cm, 2009.
우리들의 비밀 2 77×109 장지에 채색 2009

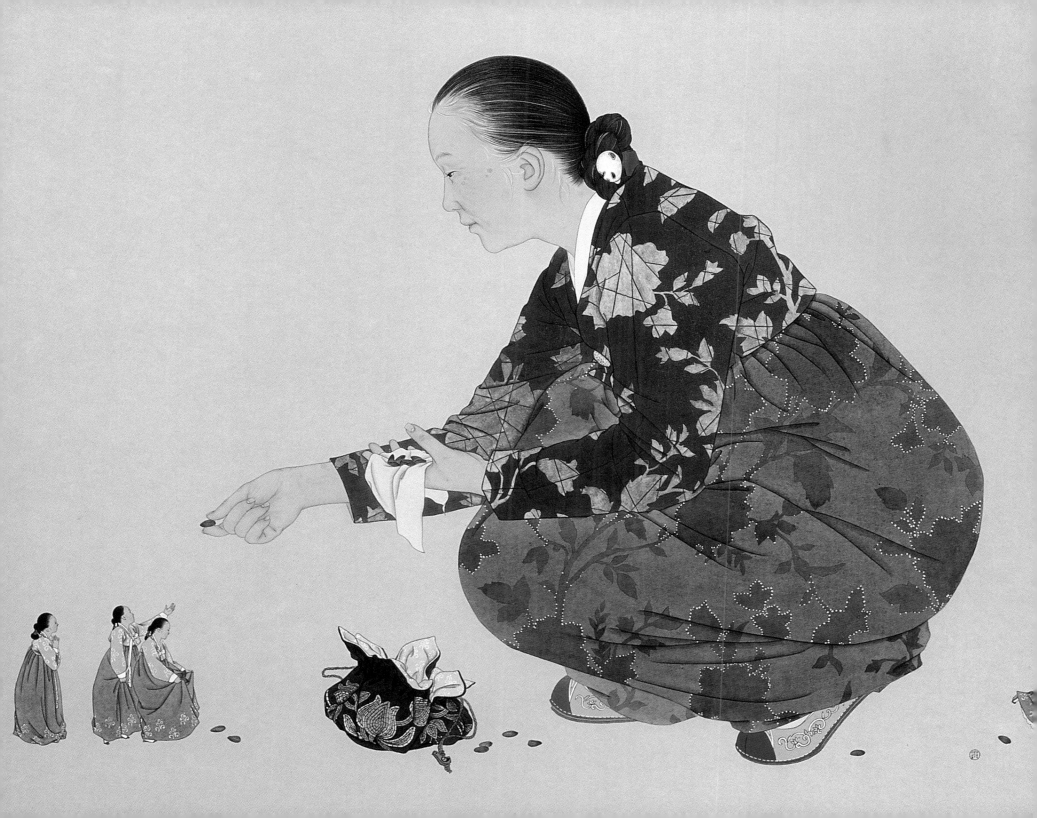

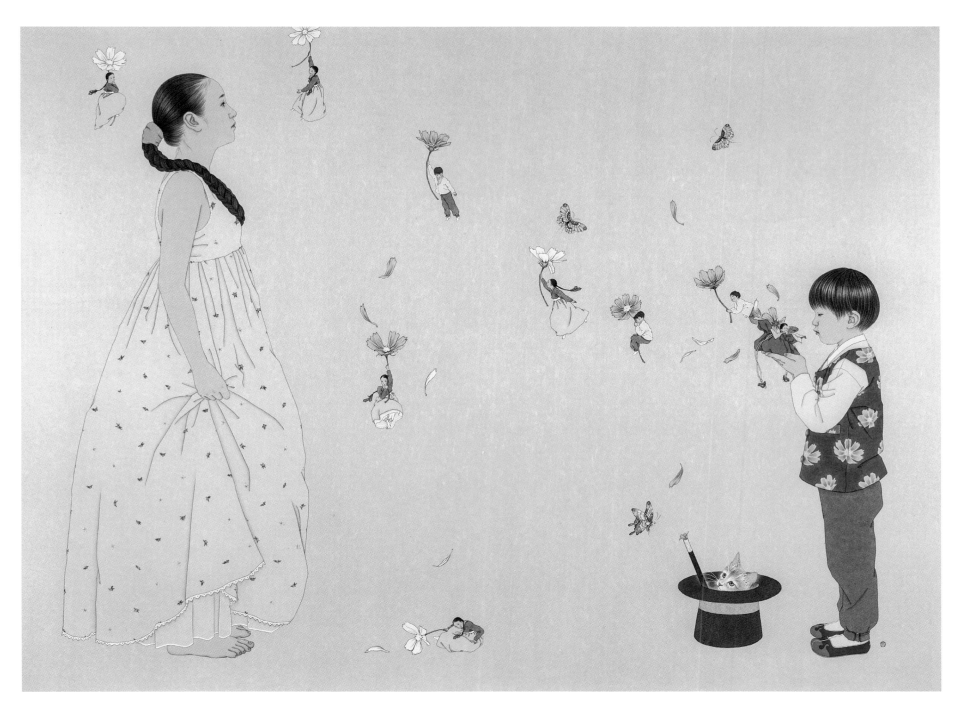

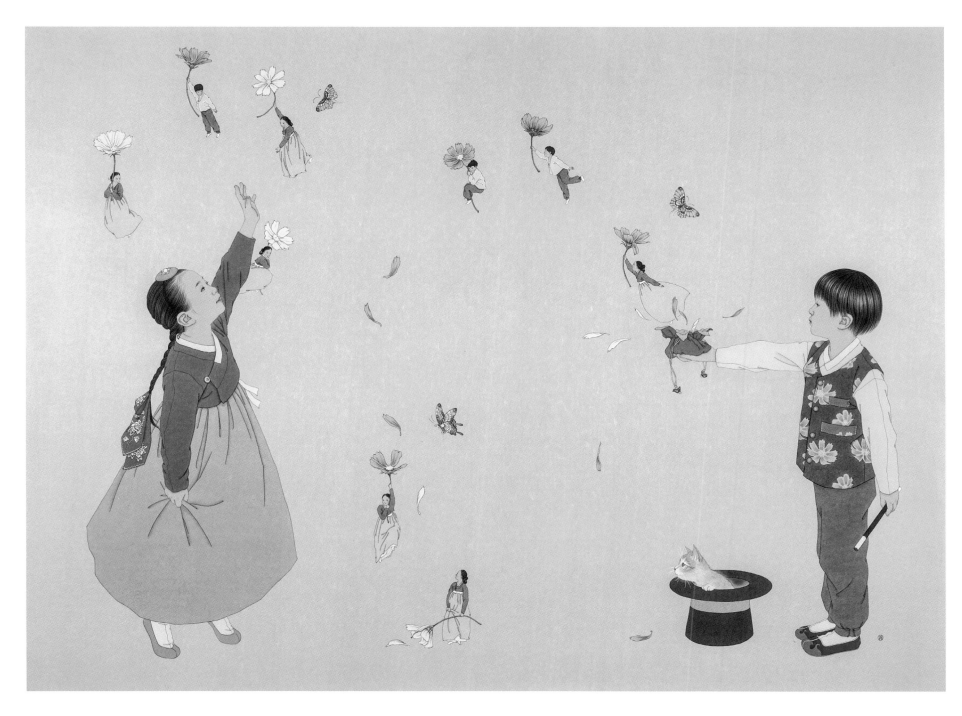

Reunion 17, ink and color on thick mulberry paper, 119×162cm, 2016.
다시 만나다 17 119×162 장지에 채색 2016

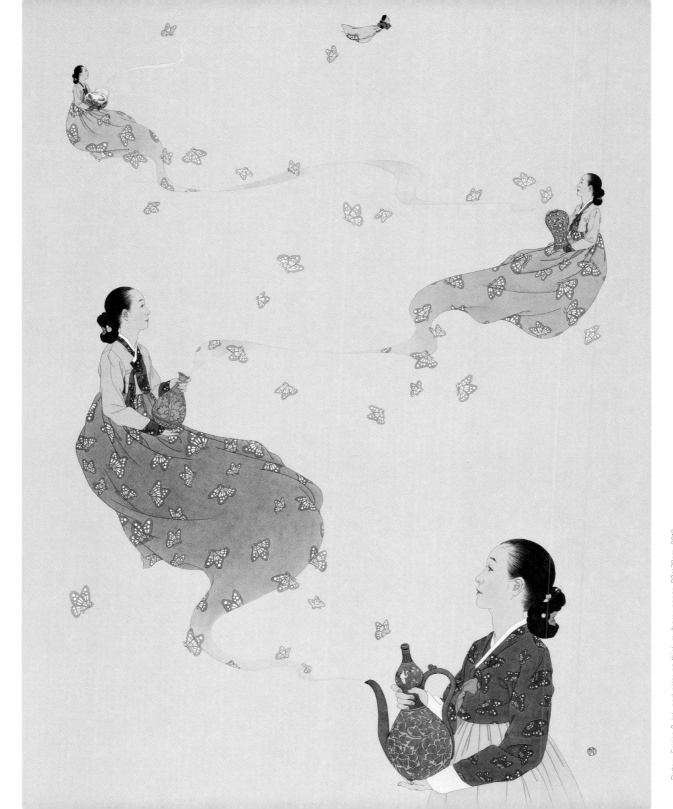

Pottery Fairies 2, ink and color on thick mulberry paper, 93×70cm, 2013.
도자기 요정 2 93×70 장지에 채색 2013

Imaginary Spaces

Lying in my room, I gaze unseeing at patterns on the wallpaper.
Then looking carefully into the complex abstract patterns,
I find intriguing new spaces emerging one after another.
And from the imaginary spaces in the patterns the ant fairies appear.

상상의 공간

방안에 누워서 벽지의 문양을 나도 모르게 계속 들여다볼 때가 있다.
벽지의 문양처럼 추상적이고 복잡한 문양을 찬찬히 들여다보면
새롭고 재미난 공간들이 하나둘씩 나타나기 시작한다.
그 문양 속 새로운 상상의 공간에 개미요정들이 나타났다.

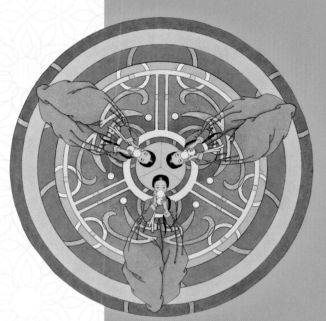

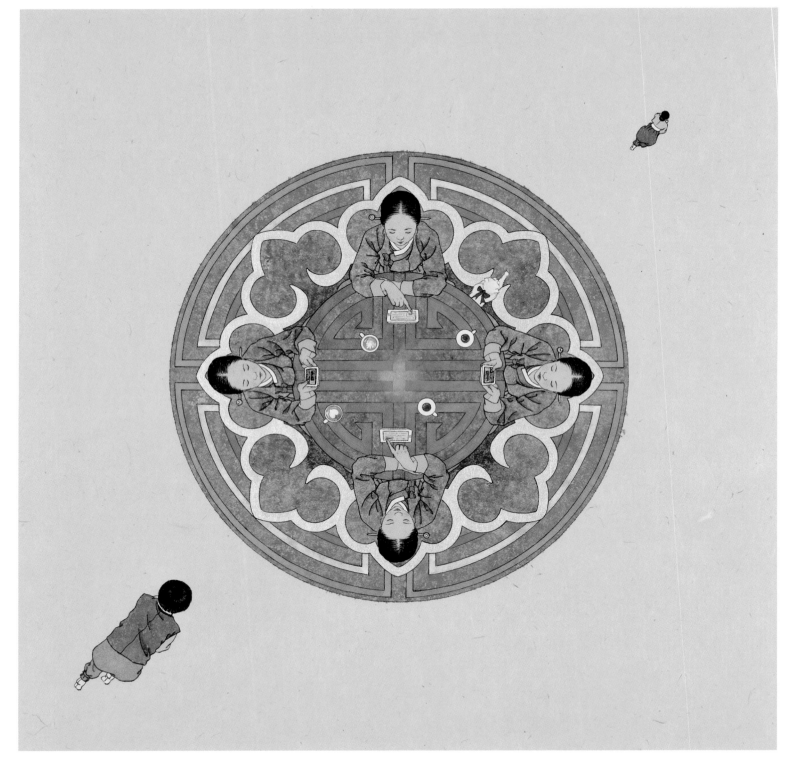

Pattern Story 2, Ink and color on thick mulberry paper, 50×50cm, 2013,
문양이야기 2 50×50 장지에 채색 2013

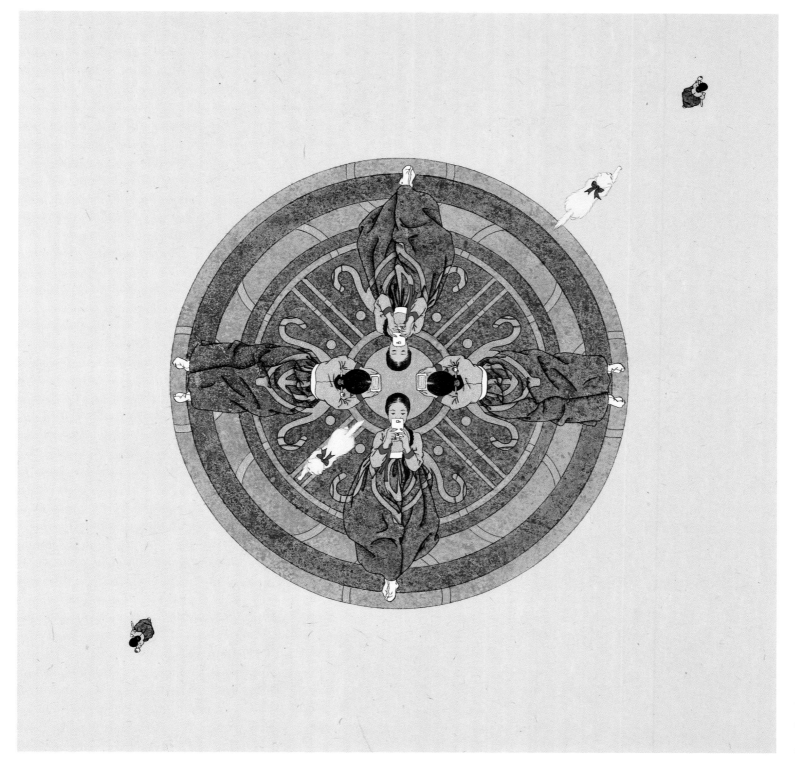

Pattern Story 4, ink and color on thick mulberry paper, 50×50cm, 2013.
문양이야기 4 50×50 장지에 채색 2013

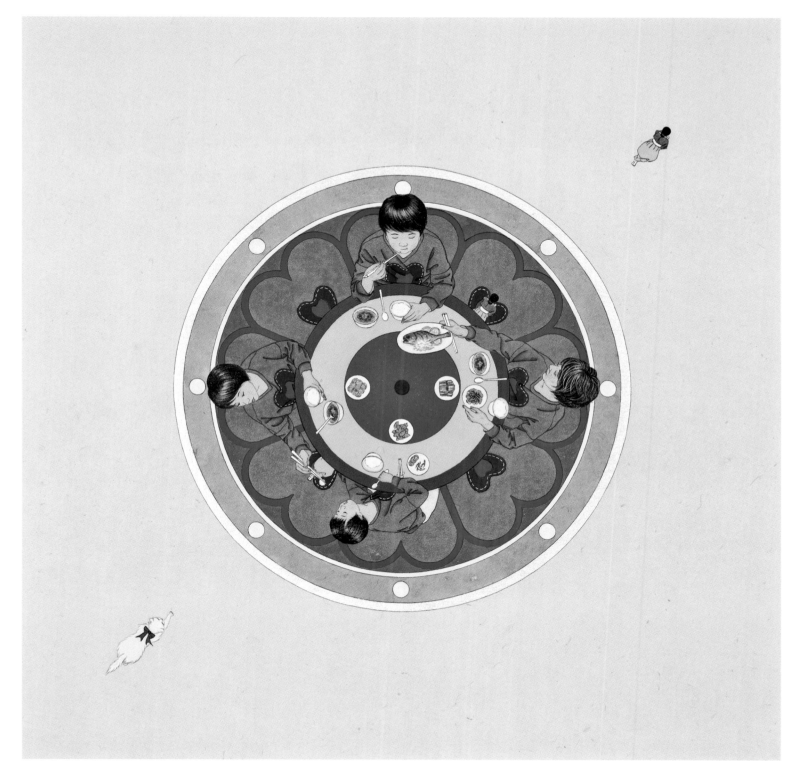

Pattern Story 5, Ink and color on thick mulberry paper, 50×50cm, 2013.
문양이야기 5 50×50 장지에 채색 2013

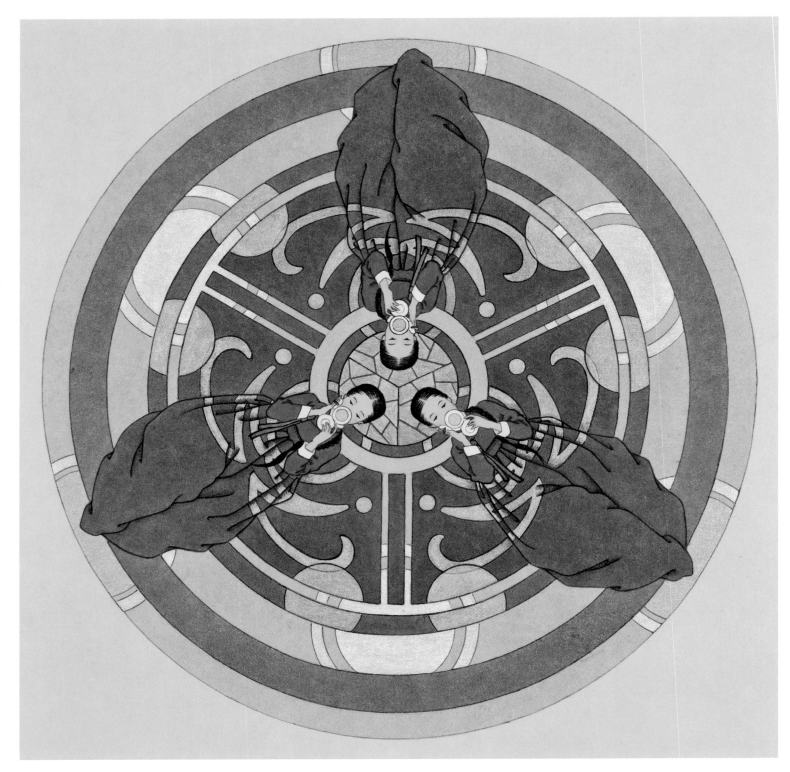

Pattern Story 7, Ink and color on thick mulberry paper, D, 30cm, 2015,
문양이야기 7 저륨 30 장지에 채색 2015

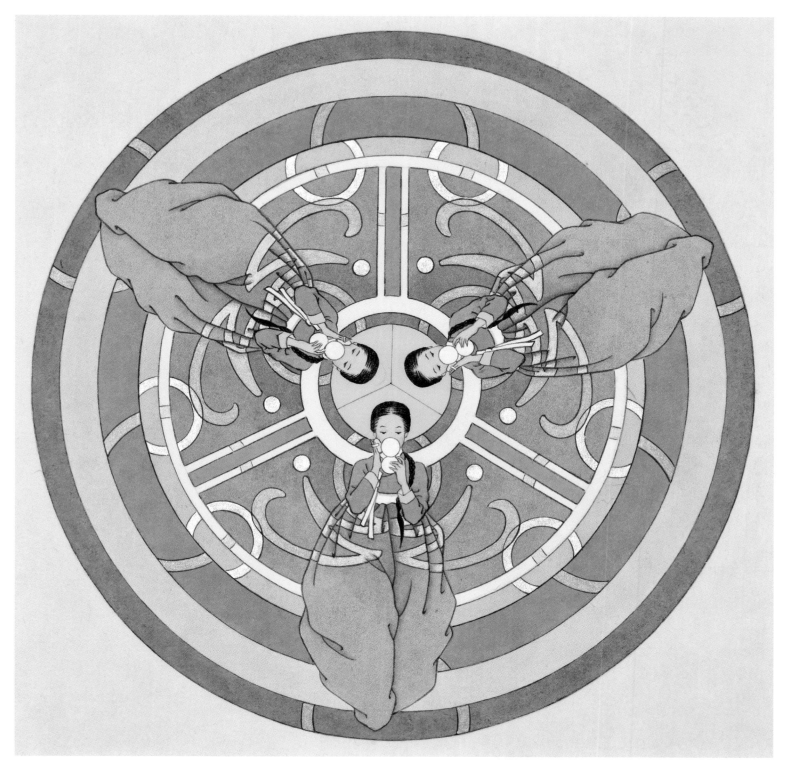

Pattern Story 8, Ink and color on thick mulberry paper, D, 30cm, 2015,
문양이야기 8 지름 30 장지에 채색 2015

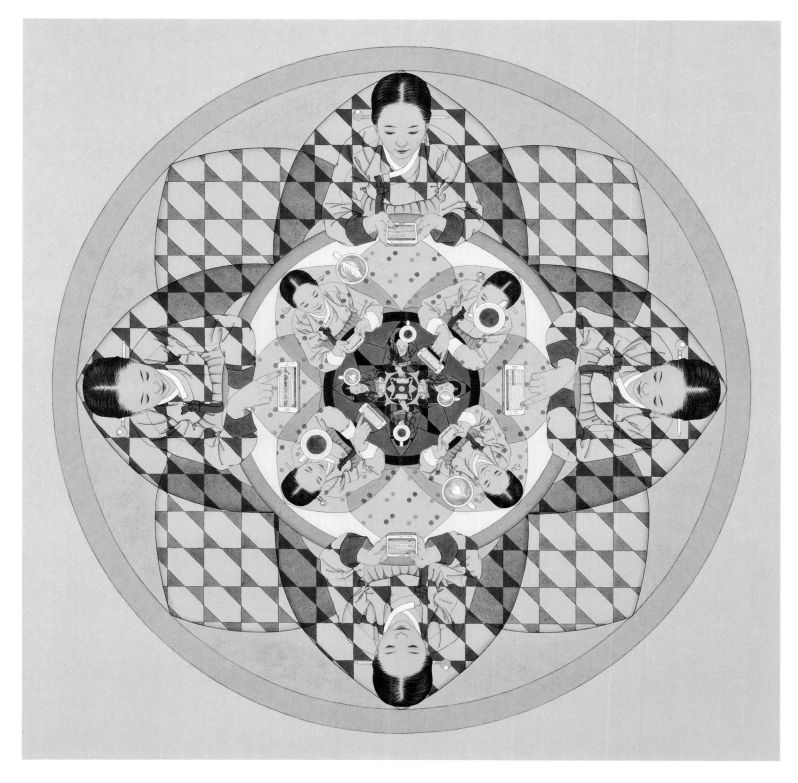

Pattern Story 6, Ink and color on thick mulberry paper, 80×80cm, 2014,
문양이야기 6 80×80 장지에 채색 2014

Korea, China and Japan

Korea, China and Japan are neighbors that are near yet far from one another.
These paintings express my wishes that the three nations
would rise above their histories of conflict and get along peacefully.
People from the three countries share ages-old traditions of string music
with many similarities that they can enjoy together in a harmonious atmosphere.
Images of people absorbed in their electronic gadgets epitomize
and satirize technology addiction as emblematic of societal atomization and alienation.
This is a call for the imperative of face-to-face conversation.

그림 속 세 나라

가까우면서도 먼 나라 한국과 중국, 그리고 일본.
이 시리즈는 세 나라가 그림 속에서는
사이가 좋았으면 하는 바람으로 시작했다.
오랜 시간을 얽혀온 만큼 서로의 문화가 닮은 점도 많기에
그들이 함께 풍류를 즐기며 화합하는 모습을 담고 싶었다.
한편 스마트 기기에 익숙해져 버린 현대인들을 풍자함으로써
올바른 대화 방식의 필요성을 강조하기도 했다.

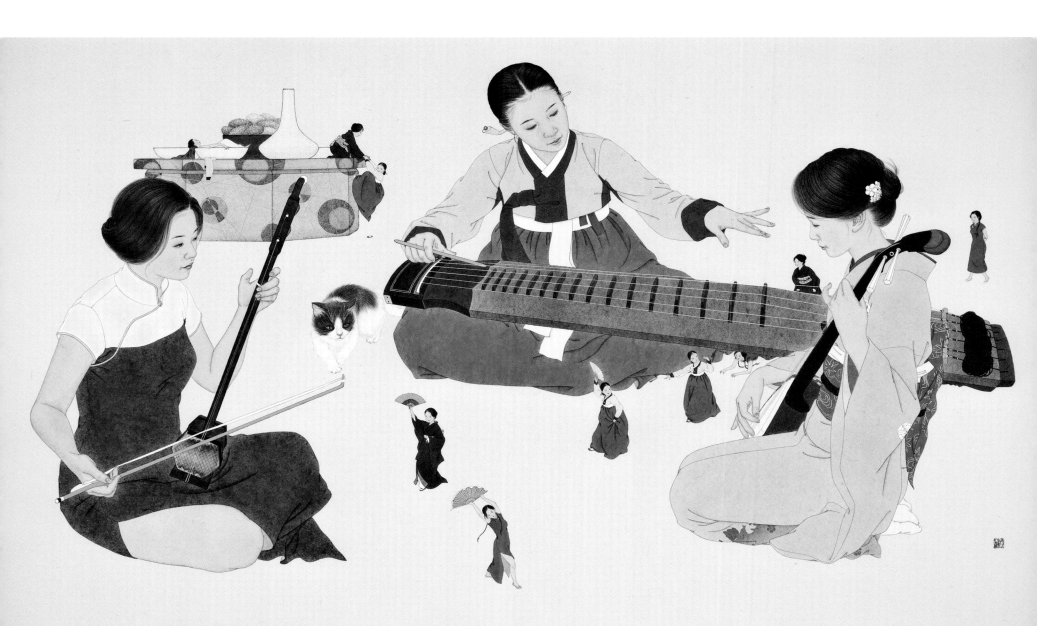

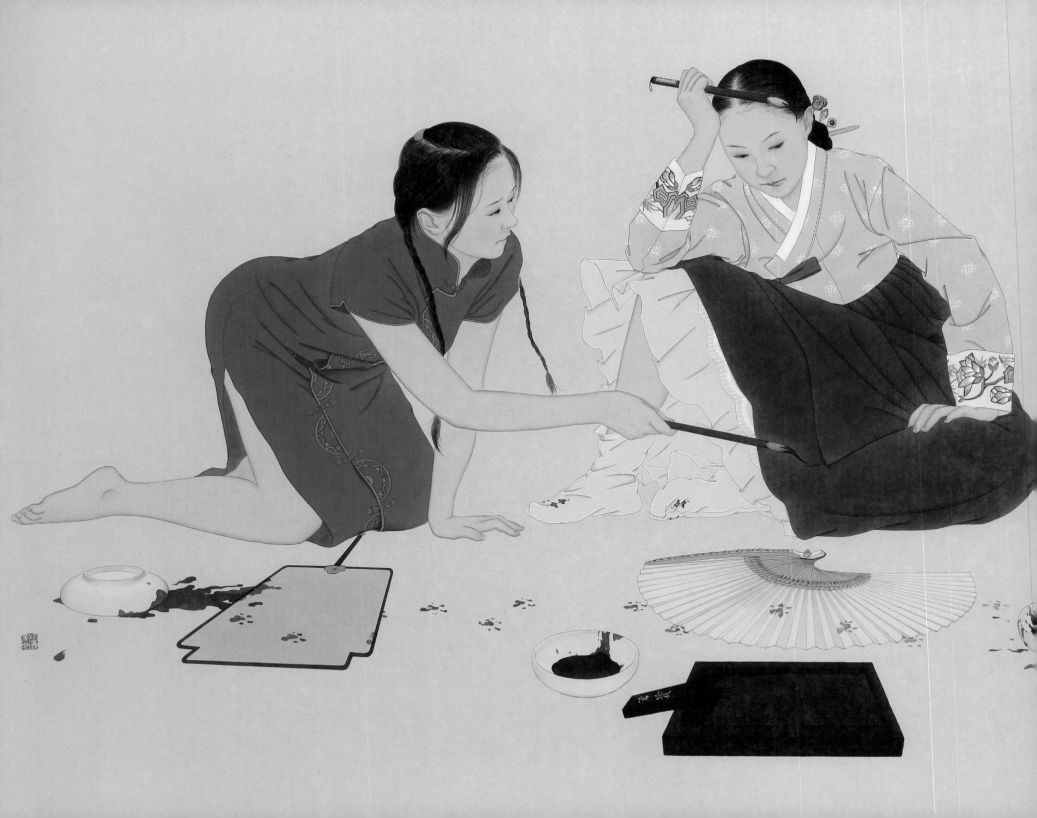

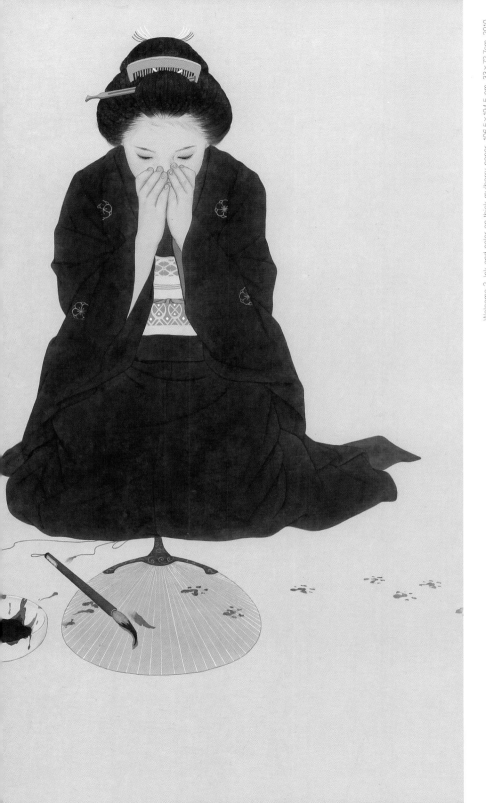

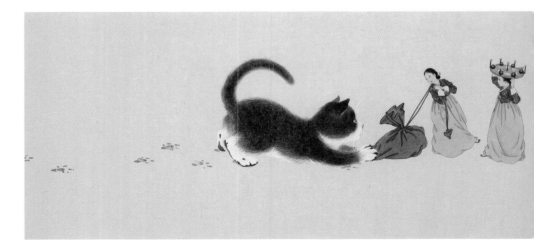

Welcome 2, Ink and color on thick mulberry paper, 106.5×194.5 cm, 33×72.7cm, 2010,
Welcome 2 106.5×194.5, 33×72.7 장지에 채색 2010

Welcome, Ink and color on thick mulberry paper, 130×162cm, 26×26cm, 2010.
Welcome 130×162, 26×26 장지에 채색 2010

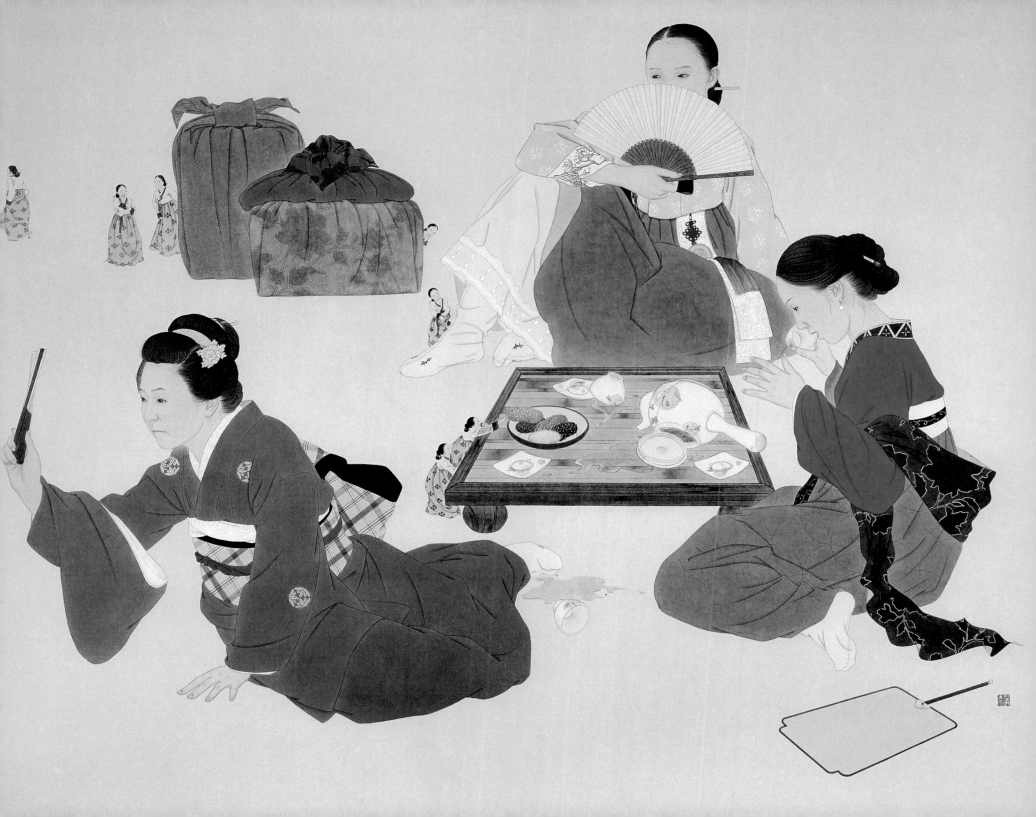

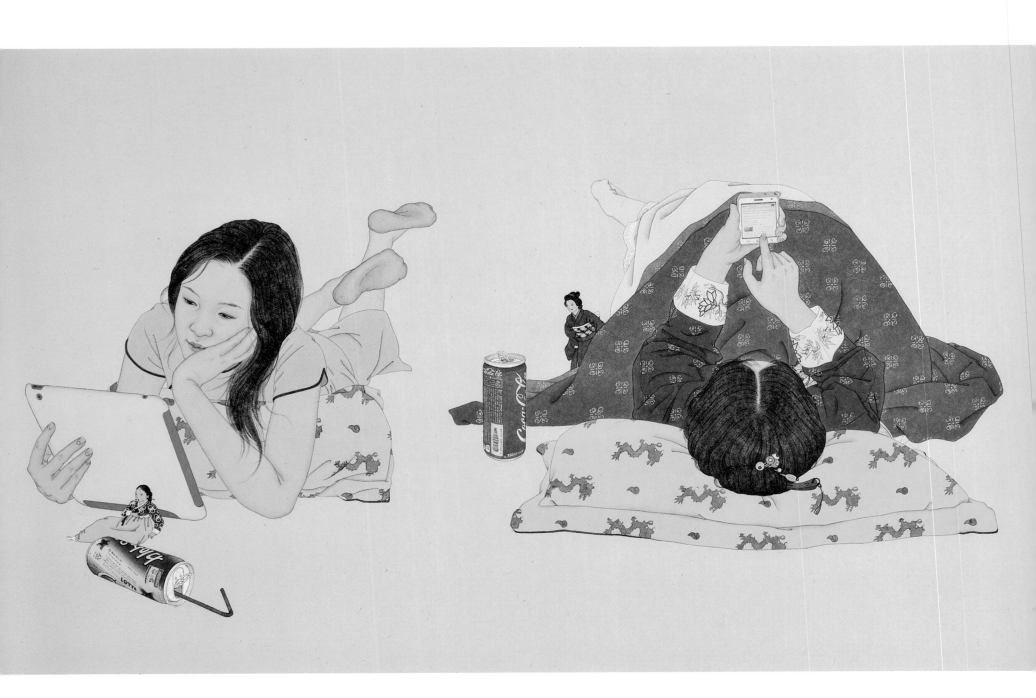

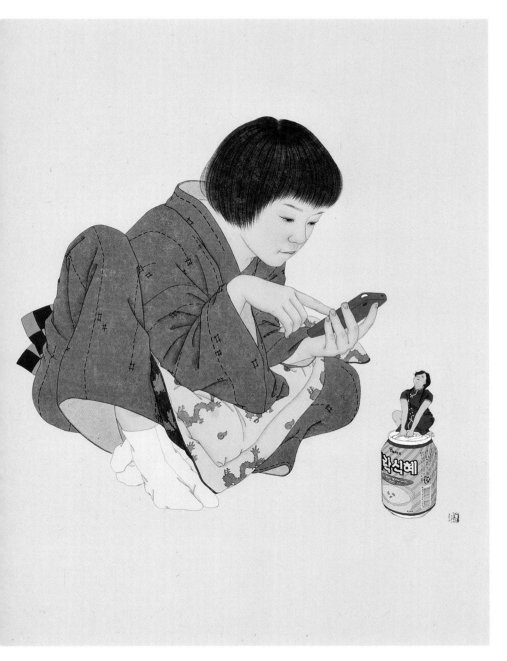

Talk, Ink and color on thick mulberry paper, 78.5×191cm, 2012,

Talk 78.5×191 장지에 채색 2012

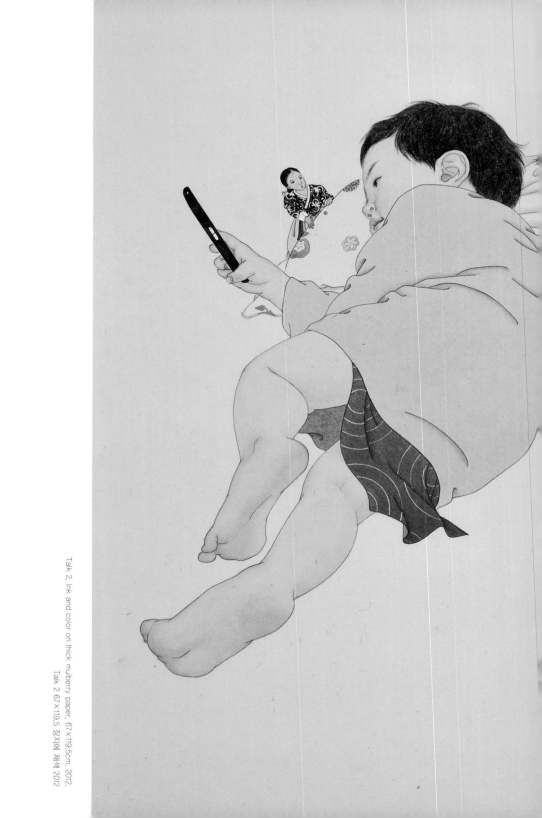

Talk 2, ink and color on thick mulberry paper, 67×119.5cm, 2012.
Talk 2 67×119.5 장지에 채색 2012

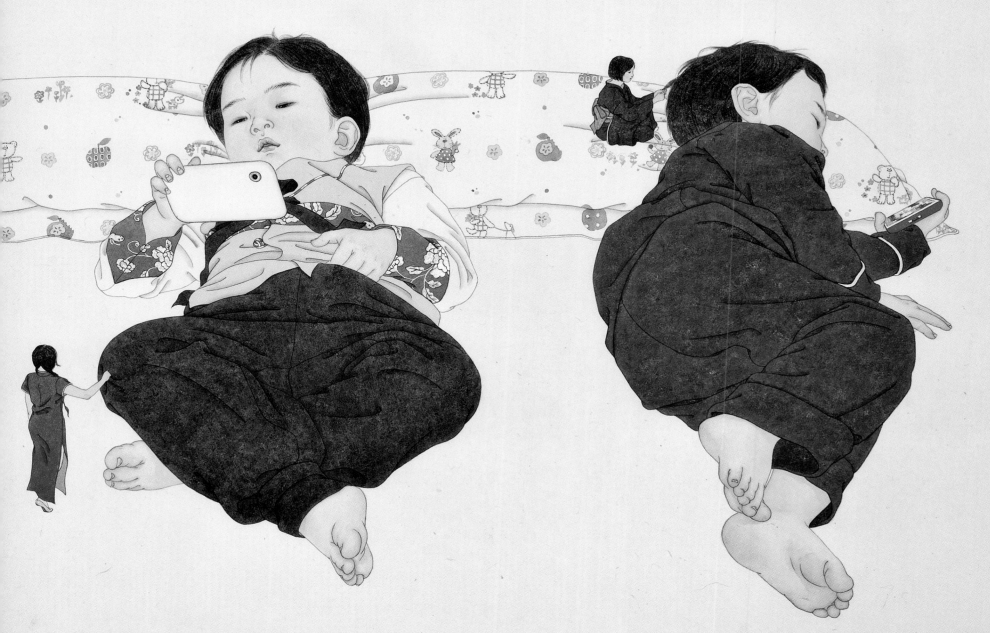

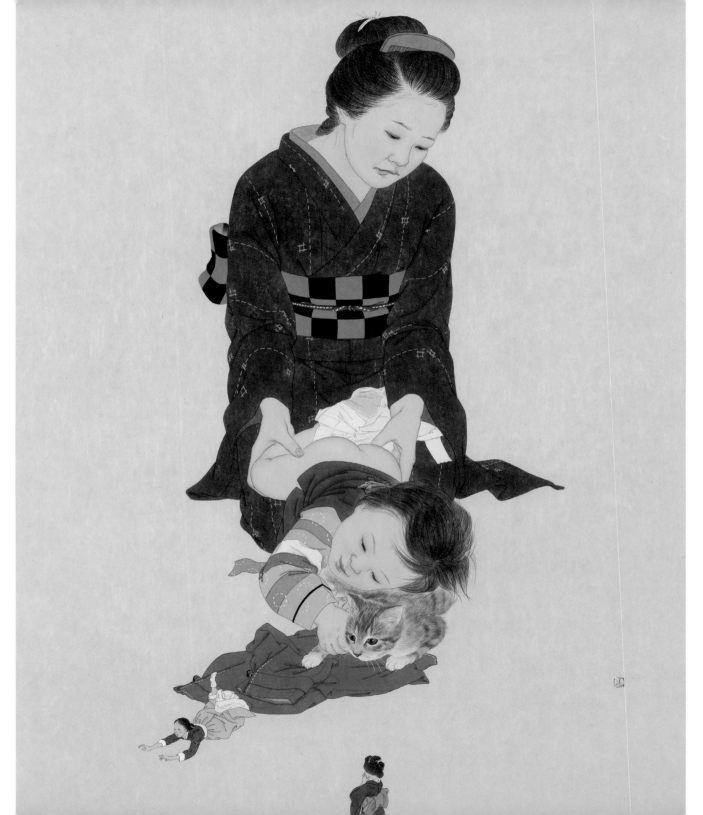

A Business of Their Own 3, Ink and color on thick mulberry paper, 99.5×78cm, 2011.
그들만의 사정 3 99.5×78 장지에 채색 2011

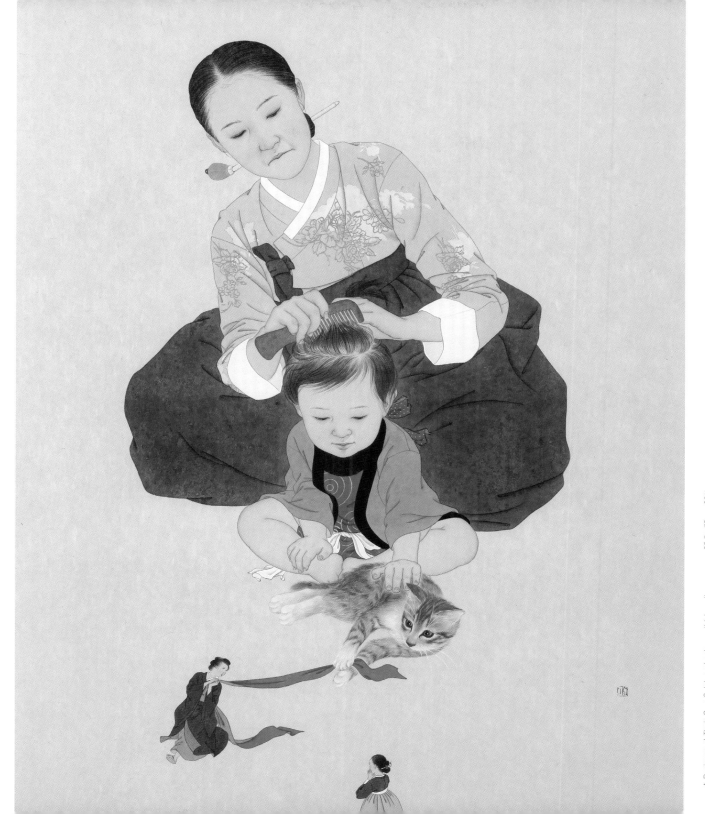

A Business of Their Own 2, Ink and color on thick mulberry paper, 99.5×78cm, 2011,
그들만의 사정 2 99.5×78 장지에 채색 2011

Welcome 3, ink and color on thick mulberry paper, 107×162cm, 2011.

Welcome 3 107×162 장지에 채색 2011

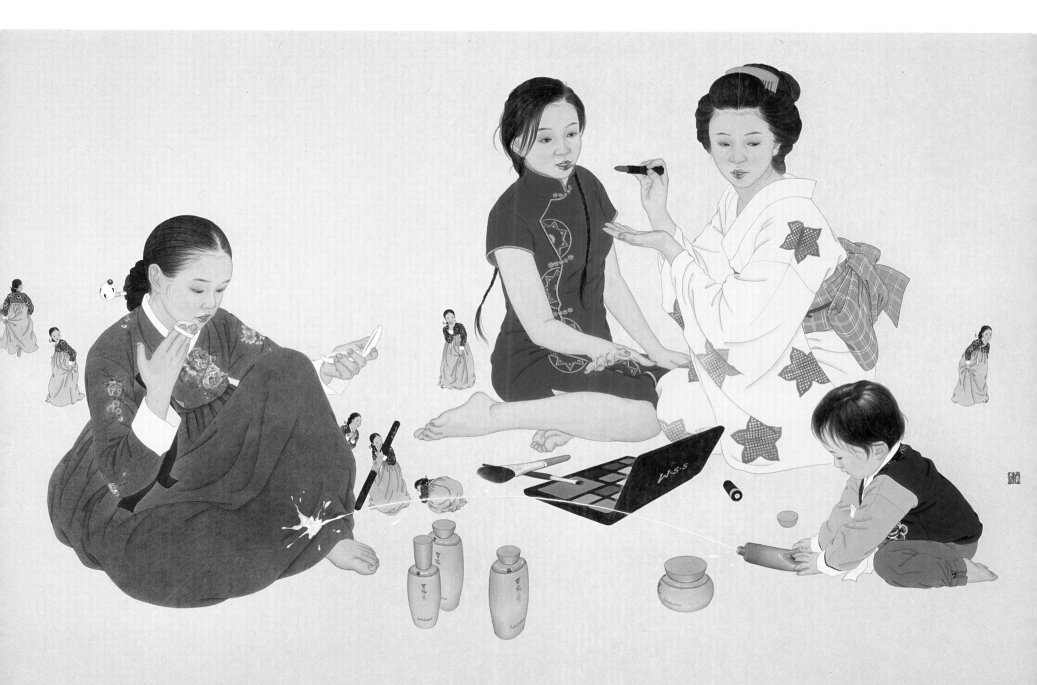

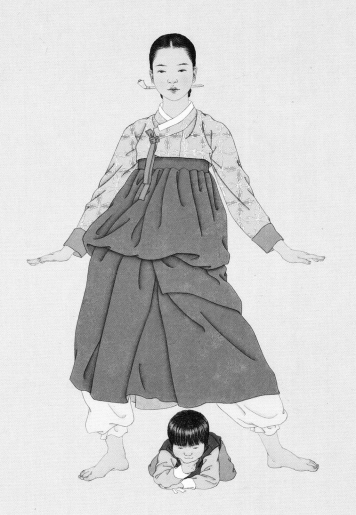
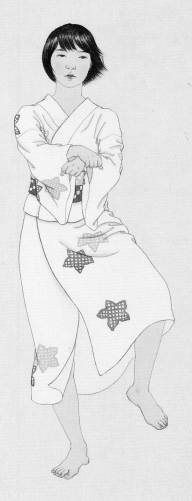

Hanbok and Korean Folk Culture in Shin Sun-mi's Paintings

Paintings by Shin Sun-mi are generally large in dimensions, in which human figures and background objects are depicted in realistic precision.

The human figures are clad in *hanbok*, the traditional Korean dress, with backdrops and props providing glimpses of traditional Korean culture.

Let us look into the beauty and style of *hanbok* and traditional Korean folk culture.

신선미의 작품 속에 등장하는 한복, 한국문화

신선미의 실제 그림은 크기는 제법 크고, 인물의 옷차림과 표정, 배경 사물 하나하나가 매우 세밀하게 표현되어 있다.

그림 속 인물들은 한복을 입고 있고, 도처에 배치된 소품들은 한국 전통문화를 엿볼 수 있는 것들로 가득하다.

그림 속에 돋보기를 들이대고, 한복의 아름다움과 한국 전통문화의 멋을 느껴보자.

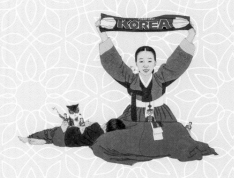

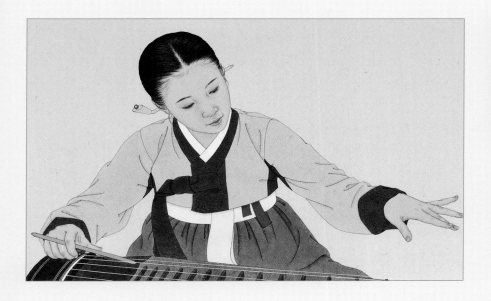

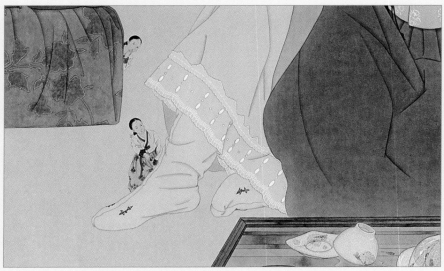

저고리 Jacket (*jeogori*)

한복 윗옷의 하나. 길, 소매, 섶, 깃, 동정, 고름, 끝동, 회장 따위가 갖추어져 있다.
솜을 두지 않고 겹으로 지은 겹저고리와 안에 솜을 두어 만든 핫저고리가 있다.
조선시대에는 저고리 색으로 신분이나 결혼 여부를 알 수 있었다.

A traditional Korean jacket typically has a V-shaped neckline with an attached
white neckband (*dongjeong*), an inset collar (*git*) and frontal gussets (*seop*), long
sleeves (*somae*) with curved underarm, and long ribbons (*goreum*) tied on the
front. The jacket is either lined or unlined. In the olden days, the style and color
of a jacket indicated the wearer's social class and marital status.

속치마 Underskirt (*sokchima*)

한복을 입을 때 속에 받쳐 입는 치마다. 조선시대에는 무지기 치마라는 속치마가
있었다. 상류층 부인들이 입던 속치마의 하나로 치마를 입을 때 속에 받쳐 입어
겉치마를 풍성하게 보이도록 했다. 길이가 서로 다른 치마 여러 개를 허리에 달아
층이 지도록 했는데, 층의 수에 따라 3합, 5합, 7합 등이 있었다고 한다.

Traditional Korean women's dress is worn over a white underskirt. Upper-class
women of the Joseon period (1392–1910) wore multi-tiered underskirts
resembling Western petticoats to create a rich silhouette when they were dressed
up. These underskirts, called *mujigi chima*, had three, five, or seven layers.

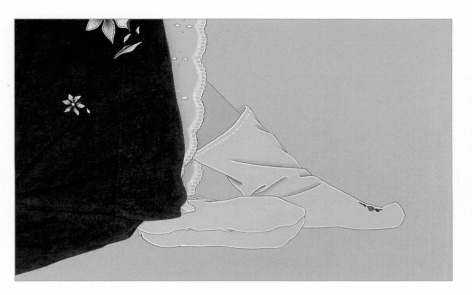

버선 Socks (*beoseon*)

버선은 한복을 입을 때 맨발에 꿰어 신는 한국의 양말이다. 무명이나 광목천으로 만든다. 만드는 방법에 따라 홑버선, 겹버선, 솜버선, 누비버선 등이 있고, 어린이용 버선으로 꽃버선과 타래버선이 있다. 버선은 치맛자락의 아름다운 선을 살려주는 중요한 장신구로 발에 잘 맞는 것을 선택한다.

White socks made of cotton fabric and characterized by smoothly curved lines and a pointed toe, worn with traditional Korean clothing, are called *beoseon*. The socks are either fine or coarse, and come unlined (*hot beoseon*), lined (*gyeop beoseon*), cotton-padded (*som beoseon*), or cotton-padded and quilted (*nubi beoseon*). Children's socks are decorated with floral designs (*kkot beoseon*) or tassels (*tarae beoseon*).

꽃신 Flower shoes (*kkotsin*)

꽃 모양이나 여러 가지 빛깔로 곱게 꾸민 신발이다. 주로 어린아이나 여자들이 신는다. 비단에 꽃자수가 놓여진 꽃신은 그 자체로서 아름다움을 지니고 있을 뿐만 아니라 선이 아름다운 한복의 멋을 발끝까지 연장시켜준다. 꽃신은 버선과 함께 여성 한복의 아름답고 고운 선을 살려주는 중요한 요소다.

Shoes decorated with colorful floral patterns are worn mostly by children and women. Silk shoes with floral embroidery add the perfect final touch to the formal elegance of *hanbok*, the traditional Korean dress. The shoes go beautifully well with *beoseon*, the Korean white socks distinguished by subtle, curved lines.

장신구 Personal Ornaments

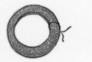
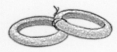

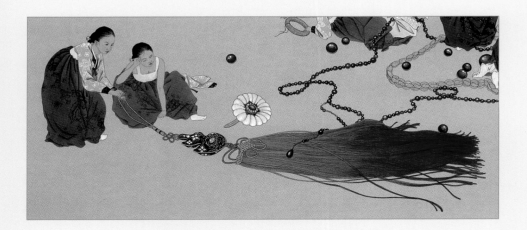

노리개 Pendant (norigae)

여자들이 몸치장으로 한복 저고리의 고름이나 치마허리에 다는 물건이다. 주로 금, 은, 보석 따위에 명주실을 늘어뜨린 것으로, 궁중에서는 물론 상류사회와 평민에 이르기까지 널리 애용된 장식물이다. 일반적으로 고려시대까지 허리춤에 달던 노리개는 고려 말부터 저고리가 짧아지면서 저고리 밑으로 올라오게 되었다. 부귀다남 등 여인들의 소망이 담긴 장신구로서 역할을 하였고, 그 모양은 매미, 박쥐, 가지, 천도, 투호 등 아주 다양하다. 노리개는 그 형태와 재료 등이 가풍을 상징한다 하여 부유한 양반 가문에서는 자제에게 이를 물려주는 풍습이 있었다.

When dressed in traditional style, women wear a pendant suspended from her jacket ribbon or the chest band of her skirt. A pendant consists of three parts: the main ornament usually made of gold, silver or gemstones, a loop on top, and long tassels made of silk thread. In the olden days, women of all social classes from royalty to commoners loved to wear this accessory. These pendants were originally worn at the waist, but as the jacket grew shorter toward the end of the Goryeo period (918–1392), they came to be suspended from the chest. The ornaments were shaped in various designs symbolizing wishes for wealth, high social status and many sons, such as cicadas, bats, eggplants, heavenly peaches, and pitch-pots (tuho). The pendants also symbolized family legacies, and were passed down to children in families of the wealthy and the nobility.

가락지 Ring (garakji)

백년회로의 언약에 있어서 가장 중요시하는 상징물이다. 반지는 그 재료가 다양하여 금, 은을 비롯하여 칠보, 호박, 옥, 비취 등을 주로 애용한다. 여름에는 시원한 느낌의 은반지나 옥, 비취 등의 반지를 겨울에는 금과 칠보 등 따뜻한 느낌을 주는 반지를 착용한다.

Rings are the most important symbol of wedding vows. They are made of gold, silver, cloisonné, amber, or jade. Jade or silver rings are favored in summer as they are regarded to have cooling properties, while gold or cloisonné rings, considered warming, are popular in winter.

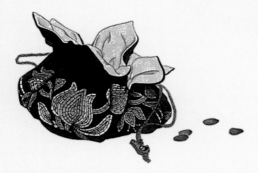

복주머니 Lucky pouch (bokjumeoni)

복을 비는 뜻으로, 주로 정초에 어린이에게 나누어주는 두루주머니. 그 속에 쌀, 깨, 조, 팥 따위 곡식을 넣어 아이들의 옷고름에 매어준다. 하지만 복주머니는 남녀노소 구분 없이 즐겨 찼다. 갖가지 색깔의 비단이나 무명천으로 만들어 과거 여인들이 장신구의 일종으로 사용하기도 했다.

Small, colorful pouches were tied to the jacket ribbon of children on New Year's Day as an expression of wishes for good luck. A few grains of rice, sesame seed, millet, or red bean were put inside. Pouches like this were worn by men and women of all age groups. In particular, women used pouches made of silk or cotton fabric in various bright colors as personal ornaments.

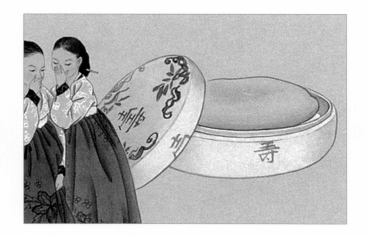

분첩과 분용기 Powder puff and container (buncheop and bunyonggi)

과거에도 분을 담아두는 분용기나 분접시, 연지첩 등 다양한 화장 도구가 있었다. 분은 도자기로 만든 분첩 용기에 채워 사용하고, 화장품을 개는 데 쓰는 물을 '분수'라는 그릇에 담아 썼다. 분이나 연지가루 등을 덜어 물에 개거나 재료들을 섞는 데 사용하는 분접시도 있었다. 분첩은 분을 묻혀 바르는 데 쓰는 화장 도구다.

Women of premodern times used diverse kinds of beauty aids and accessories. Powder was contained in decorated ceramic boxes, and mixed with water kept in a separate container called *bunsu* on a plate every time it was needed. Rouge for cheeks and lips were also prepared in the same way.

비녀 Long hairpin (binyeo)

비녀는 뒤쪽에서 가지런히 모아 정리한 쪽머리를 가다듬고 고정하는 역할 이외에도 장식의 의미가 크다. 주로 결혼한 여자가 한다.

A long hairpin is mainly for the practical purpose of fixing a chignon at the nape and holding it in place, but it also has outstanding ornamental effects. Only married women use this type of hairpin.

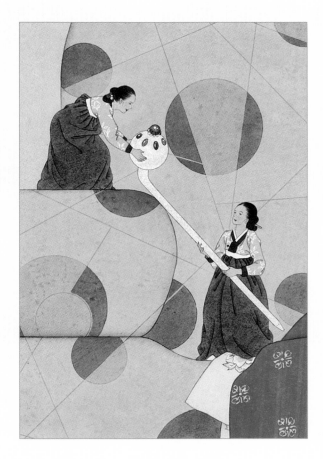

참빗 Fine-tooth comb (chambit)

한국의 전통 빗에는 얼레빗, 참빗, 면빗, 상투빗 등이 있다. 머리를 땋거나 쪽을 찌던 조선시대에는 먼저 빗살이 성긴 얼레빗으로 머리카락을 가지런히 하고, 촘촘한 참빗으로 정성 들여 빗어내려 땋거나 쪽을 쪘다. 그런 다음 작은 면빗으로 정갈하게 다듬었다. 모양은 대부분 반달형과 직사각형이며, 재료로는 박달나무, 대나무, 대추나무, 도장나무, 소나무 등이 사용되었다.

In premodern Korea, both men and women wore their hair long. Young girls and boys had a braided pigtail; married women wore their hair in a chignon fixed at the nape with a long hairpin and married men had a topknot. Different kinds of combs were needed for different purposes: fine-tooth combs (*chambit*), wide-tooth combs (*eollebit*), small combs for final touches (*myeonbit*), and topknot combs (*sangtubit*). They were mostly in half-moon or rectangular shapes, made of wood from birch, bamboo, jujube, boxwood, and pine trees.

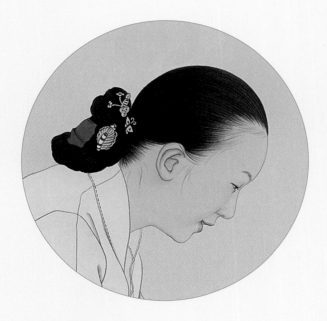

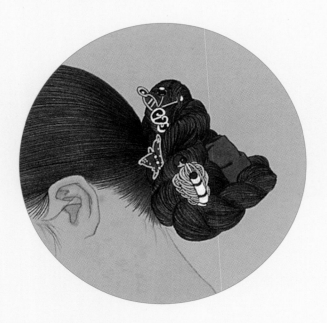

쪽머리 Chignon (jjokmeori)

쪽머리는 시집간 여자가 뒤통수에 땋아서 틀어 올려 비녀를 꽂은 머리를 말한다. 기혼녀의 보편적인 머리 모양으로 조선 중엽부터, 영조 시대 가체 금지령 이후 족두리를 벗고 쪽머리가 보편화되었다. 가르마를 타 곱게 빗어 뒤로 길게 한 줄로 땋아서 댕기로 끝을 묶은 다음 쪽을 만들어 비녀로 고정시켰다. 원래는 관례를 한 직후 쪽 머리를 했지만 차츰 관례가 없어지면서 기혼녀 머리의 상징이 되었다.

In premodern Korea, married women wore their hair (*meori*) in a braided chignon, called *jjok*. This became a common hairstyle of married women after large wigs were forbidden by the government during the reign of King Yeongjo (r. 1724–1776) of the Joseon Dynasty. They had their hair neatly parted at the center and braided in a single rope, tied with a thin ribbon at the end, then rolled up in a small chignon and fixed with a long hairpin at the nape. Young women used to have their pigtail fixed in this style after their coming-of-age rite, but as the ritual gradually disappeared they adopted this hairstyle upon marrying.

뒤꽂이 Ornamental hairpin (dwikkoji)

뒤꽂이는 쪽머리 뒤에 덧꽂는 비녀 이외의 장식물을 총칭한 것으로 끝이 뾰족한 단순한 뒤꽂이 이외에 실용적인 면을 겸한 귀이개, 빗치개 등이 있다. 재료와 두식頭飾에 따라 종류가 다양하나 일반 뒤꽂이 가운데 가장 많이 애용된 것은 화접뒤꽂이로 매화나 국화 사이에 호랑나비가 앉은 것과 연꽃봉오리 모양의 장식이 달린 연봉뒤꽂이가 있다. 이밖에 비취, 산호, 진주 등을 사용하여 매우 화려하게 만들었다.

Hairpins of this type are more ornamental than functional. They are additionally put in a chignon along with a long hairpin. Some are simply for decorating a chignon, sometimes they are also used for cleaning ears or combs. These hairpins come in a great variety of materials and ornaments. Among the most popular kinds were those with swallowtail or lotus bud design. The former would have a swallowtail perched between plum and chrysanthemum flowers. Luxurious hairpins are decorated with jade, coral, or pearl ornaments.

댕기머리 Hair ribbon (daenggi)

댕기는 길게 땋은 머리끝에 드리는 장식용 끈을 말한다. 삼국시대부터 조선시대까지 사용되었다. 쓰임에 따라 쪽댕기, 제비부리댕기, 큰댕기, 앞댕기, 어린이용 댕기가 있다. 댕기머리는 주로 혼인을 하지 않은 남녀와 어린아이들이 했으며, 그렇기에 댕기머리(떠꺼머리)는 총각, 처녀라는 의미로 사용되었다.

For some 2,000 years from the Three Kingdoms to the Joseon periods, Korean boys and girls wore their hair in a long braided pigtail until they married. The pigtail was tied at the end with a decorative ribbon called *daenggi*. The ribbons were in different styles depending on age and purpose. *Daenggi meori*, or *tteokeomeori*, symbolically referred to unmarried women and bachelors.

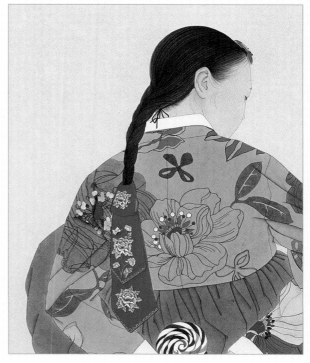

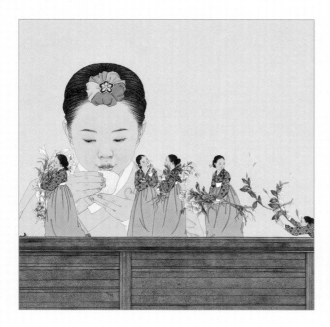

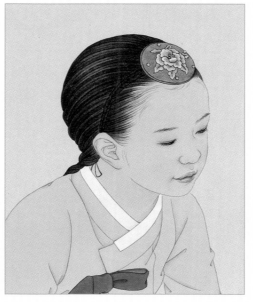

배씨댕기 | Pear-seed hair ornament (baessi daenggi)

배씨댕기는 은으로 배씨(배의 종자) 모양을 만들어 칠보로 장식한 어린이용 댕기다. 머리카락이 아직 한 줌 안에 들지 않는 서너 살 어린 여자아이의 머리장식으로 사용했다. 양편에 보조댕기를 가늘게 달아 가르마 중앙에 배씨를 놓고 양편으로 가른 머리를 바둑판처럼 나누어가며 배씨댕기와 같이 연결하여 땋아 짧은 머리를 고정시켰다. 배씨댕기는 태어나서 처음 사용하는 장신구로 병마와 액운을 막으려는 주술적 의미도 담고 있다.

This type of hair accessory adorned with cloisonné patterns resembling the cross section of the pit of a pear was for young girls who didn't yet have enough hair to make a long braided pigtail. The hair is parted along the center with the ornament front and center; then tiny braids are made on both sides and linked to the larger pigtail at the back. For many young girls, this was their first personal ornament, also worn as a charm to protect them from illness and evil spirits.

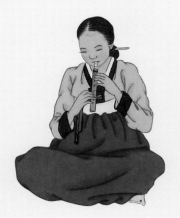

피리 Bamboo oboe (piri)

한국의 전통 관악기로 속이 빈 대에 구멍을 뚫고 불어서 소리를 내는 악기를 통틀어 일컫는다. 마디가 촘촘하지 않은 대나무로 만들며 서양의 악기인 오보에와 같이 '서(혀)'를 꽂아서 연주한다. 지공은 여덟 개이며 앞에 일곱 개, 뒤에 한 개가 있다.

Piri is one of the most common types of woodwind instruments in traditional Korean music. The cylindrical oboe is made of a bamboo tube with sparsely-spaced joints. It has eight finger holes, seven on the front and one on the back, and a bamboo reed in the mouth piece.

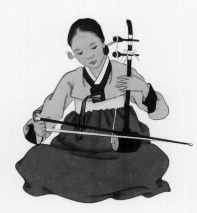

해금 Two-stringed fiddle (haegeum)

해금은 두 줄로 된 한국의 전통 찰현악기 중 하나다. 고려 예종 때에 중국 송나라에서 들어온 것으로, 속이 빈 둥근 나무의 한쪽에 오동나무 복판을 붙이고 긴 나무를 꽂아 줄을 활 모양으로 건 악기다. 명주실을 꼬아 만든 두 가닥 줄의 한쪽 끝에 공명통이 있어서 활로 줄을 마찰할 때 울리는 소리가 난다. 속된 말로 '깽깽이'라 이르기도 한다. 향악 연주에 주로 쓰인다.

One of Korea's traditional string instruments, the *haegeum* was introduced from Song China during the reign of King Yejong (r. 1105–1122) of the Goryeo Dynasty. It has a small wooden sound box made of paulownia wood, attached to a long bamboo neck with large pegs. Two silk strings are attached to the bottom of the sound box, stretching over a small wooden bridge and up the bamboo neck to the pegs. It is played by moving a horsehair bow horizontally back and forth across the strings. Also called *kkaengkkaeng-i*, denoting its high-pitched tone, the instrument is played mainly for local folk music.

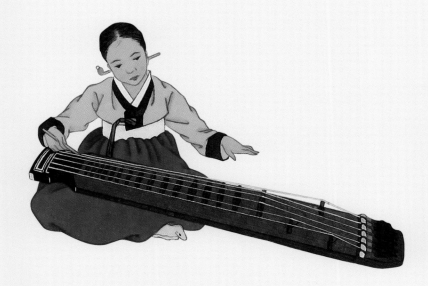

거문고 Six-stringed zither (geomungo)

한국의 전통 현악기의 하나로 오동나무와 밤나무를 붙여 만든 장방형의 통 위에 명주실을 꼬아 만든 여섯 개의 줄이 걸쳐 있다. 술대로 줄을 뜯어서 연주하는데, 관현악에 반드시 편성되며 독주 악기로도 널리 사용한다. 낮고 중후한 소리부터 높은 소리까지 넓은 옥타브의 소리를 낸다. 소리는 깊고 꿋꿋하며 장중하고 남성적이다.

Geomungo is one of the most often played string instruments in traditional Korean music. It has a rectangular sound board made of paulownia and chestnut wood panels and six silk strings laid over it with wooden movable bridges and frets. It is played by plucking the strings with a pencil-sized bamboo plectrum, called *suldae*. The instrument is played as both a solo and an ensemble instrument. It produces a deep, majestic and resonant sound from low to high pitches, exuding masculine strength.

가야금 Twelve-stringed zither (gayageum)

한국의 전통 현악기의 하나로 오동나무로 된 긴 공명판 위에 열두 줄의 명주 줄을 매고 손가락으로 뜯어 소리를 낸다. 가실왕이 처음 만든 것으로 알려져 있다. 가야금은 동아시아 전역에 널리 퍼져 있는 롱 치터long zither류의 전통악기 중 하나다. 중국의 정, 일본의 고토, 베트남의 단짜인, 몽골의 야탁 등이 여기에 해당한다. 가야금 소리는 부드럽고 서정적이며 아름답다. 한국인에게 가장 사랑받는 악기 중 하나다.

One of the most beloved string instruments in traditional Korean music, the *gayageum* produces a soft, lyrical sound. It has 12 silk strings laid along a long rectangular sound board made of paulownia wood, and is played by plucking the strings with the fingers. The instrument is said to have been made by Ureuk, a musician during the reign of King Gasil in one of the Gaya kingdoms, around the sixth century. It is similar to long zithers of other East Asian countries: China's *zheng*, Japan's *koto*, Vietnam's *dan tranh*, and Mongolia's *yatug-a*.

장구 Hourglass drum (janggu)

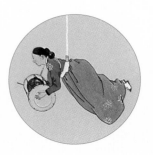

한국 전통음악에서 널리 쓰는 타악기다. 고려시대에 중국에서 전해왔다. 기다란 오동나무로 만든 것으로, 통의 허리는 가늘고 잘록하며, 한쪽에는 말가죽을 매어 오른쪽 마구리에 대고, 다른 한쪽에는 쇠가죽을 매어 왼쪽 마구리에 대어 붉은 줄로 얽어 팽팽하게 켕겨놓았다. 왼쪽은 손이나 궁채•, 오른쪽은 열채••로 치는데, 그 음색이 각기 다르다.

• 궁채: 약 30cm의 대나무 뿌리 한쪽 끝에 박달나무를 배가 불룩하게 나온 원통 모양으로 둥글게 깎은 궁알을 달고, 다른 한편은 손잡이를 붙여 만든다.
•• 열채: 대나무를 깎아서 만든다. 길이는 30~40cm, 두께는 0.2~0.3cm로 손잡이는 넓게, 그리고 채편을 때리는 부분은 가늘게 깎아낸다.

This type of percussion instrument is widely used in traditional Korean music of various genres. Introduced from China during the Goryeo Dynasty (918–1392), the drum is played horizontally. It has a paulownia wood frame resembling an hourglass, with a thick horse-skin drumhead on the right-hand side and a thin ox-skin drumhead on the left-hand side. The tension on the drumheads is adjusted by pulling the laces holding them together. It is played with a hand or a thick drumstick called *gungchae*• in the left hand, producing low-pitched sounds, and a thin bamboo drumstick called *yeolchae*•• in the right hand, producing high-pitched sounds.

• *Gungchae*: A drumstick made of a bamboo root, some 30 centimeters long, and attached with a birch wood ball at one end and a handle on the other.
•• *Yeolchae*: A drumstick made of a bamboo strip, some 30–40 centimeters long and 0.2–0.3 centimeters thick, which is wider on the handle part and narrower on the end striking the drumhead.

대금 Large transverse flute (daegeum)

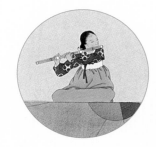

한국의 전통 목관악기 가운데 하나로 굵고 긴 대나무에 구멍을 뚫어 가로 부는 악기다. 구멍은 열세 개이며, 음역이 넓어서 다른 악기의 음정을 잡아주는 구실을 한다. 구슬프고 신비로운 소리가 나며, 역취(힘주어 붊)에서는 이와 달리 장쾌하고 맑은 소리가 난다.

Daegeum is one of Korea's traditional woodwind instruments. A long bamboo tube with 13 finger holes, the instrument produces a wide range of tones so it offers standard keys for other instruments. It makes a soulful, mournful sound, but when played powerfully, the sound turns pure and exciting.

징 Large gong (jing)

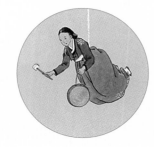

민속음악에 쓰는 타악기의 하나. 놋쇠를 사용해 큰 그릇 모양으로 징을 만들고, 끈을 매달아 손에 쥐고 채를 이용해 치거나 나무로 만든 틀에 묶고 친다. 음색이 부드럽고 장중하다.

A type of percussion instrument used in traditional Korean folk music, the *jing* is made of brass in the shape of a large bowl. It is either held in one hand by a string on one side, or hung on a wooden rack, and struck with a drumstick with its head wrapped in cloth. It produces a resonant sound of mellow and sonorous tone.

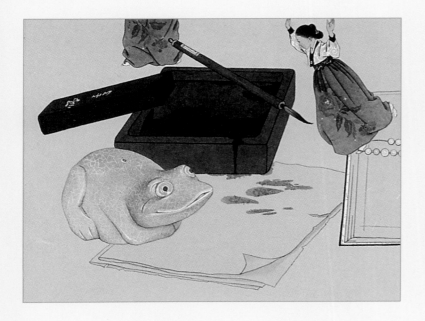

문방사우 Scholar's four friends (munbang sawoo)

조선시대 선비들의 서재 즉, 문방文房에서 사용한 물건 중 종이, 붓, 먹, 벼루 이 네 가지를 문방사우文房四友라고 한다. 이것을 문방 필수품으로 생각하는 전통은 중국에서 시작되었으나 우리나라에 도입되면서 '서로 떨어질 수 없는 문방의 벗'이라는 의미로 이러한 명칭이 붙었다. 문방사우는 선비들이 애정을 갖고 소중히 다루는 필수품이었으며, 뜻이 맞는 벗들이 주고받는 의미 있는 선물이기도 하였다. 문방사우를 편리하게 사용하고 보관하기 위해 지통, 필통, 붓걸이 등의 용품이 함께 사용되었다.

Scholars of the Joseon period (1392–1910) cherished the four essential implements that no scholar's studio (munbang) could do without. These were brush, paper, ink, and inkstone. The tradition originated from China, where those articles were referred to as the "four treasures" (sibao). In Korea they came to be called the "four friends" (sawoo). They were indispensable objects used daily by scholars, often received as significant gifts exchanged between them. The scholar's studio is furnished sparely but thoughtfully to hold and store these articles safely and conveniently, along with jitong, for holding rolls of writing paper, brush holders (piltong) and brush racks (butgeori).

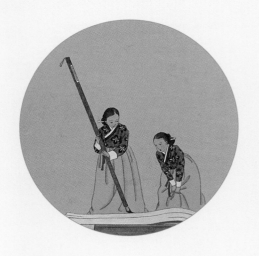

붓 Brush (but)

글씨를 쓰거나 그림을 그릴 때 쓰는 도구다. 주로 가는 대나무나 나무로 된 자루 끝에 짐승의 털을 꽂아서 먹이나 물감을 찍어 쓴다.

Brushes for writing and painting are essentially similar in shape and material. They consist of a long handle made of bamboo or wood and animal hair, which is dipped in ink or paint and applied on paper, silk or other material.

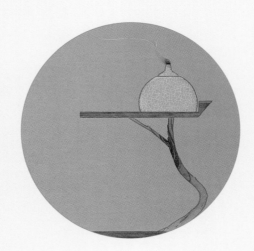

호롱 Lamp (horong)

호롱 또는 등잔은 기름을 채워 심지에 불을 붙임으로써 빛을 밝히는 조명 도구다. 호롱에 밝힌 불을 호롱불 또는 등잔불이라 한다.

Oil lamps, called horong or deungjan, were used for lighting before gas, and later, electricity, became widely available. Light from these lamps was called horongbul or deungjanbul.

도자기 Pottery

분청사기 Buncheong ware
(*Buncheong sagi*)

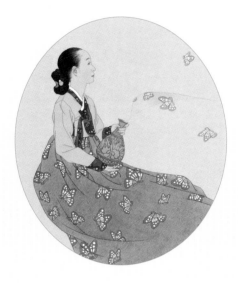

고려 말기 퇴락해가던 상감청자의 뒤를 이어 발생한 조선시대 대표 도자기다. 청자에 백토白土로 분을 발라 다시 구워낸 것으로, 회청색 또는 회황색을 띤다.

As celadon making declined toward the end of the Goryeo period, it gave way to Buncheong, or the grayish-blue stoneware decorated with white slip, which was made with simpler methods. The apparently cruder vessels produced mainly from the 14th to the 16th centuries continue to fascinate people with their natural and unassuming beauty infused with modern sensibility.

백자 White porcelain (*baekja*)

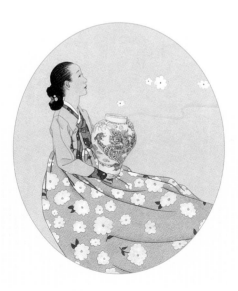

순백색의 바탕흙 위에 투명한 유약을 발라 구워 만든 자기다. 청자에 비하여 깨끗하고 담백하며 검소한 아름다움을 풍긴다. 한국 백자는 고려 말기에 송나라로부터 영향을 받아 시작되었고, 조선시대에 이르러 전성기를 이루었다.

The white porcelain wares, made of pure kaolin and covered with translucent glaze, are characterized by pure minimalist beauty. The porcelain-making technology was introduced to Korea from Song China toward the end of the Goryeo Dynasty (918–1392), and made great advances during the succeeding Joseon period.

고려청자 Goryeo celadon (*Goryeo cheongja*)

고려청자는 고려시대에 만들어진 푸른빛의 자기를 통틀어 이른다. 중국 송나라 청자의 영향을 받았으나 송의 청자와는 다른 푸른색을 개발하였다. 고려청자 중 상감청자가 특히 유명한데 상감청자는 장식무늬를 파고 그 속을 다른 재질의 흙으로 메워서 문양을 낸 청색 도자기다. 고려인의 창의성과 예술성이 돋보인다.

Green celadon wares of Song China were introduced to Korea during the Goryeo Dynasty and inspired Korean potters, who produced unique celadon wares of an enchanting bluish-green color. The master Korean potters also invented an inlaying technique called *sanggam* for embellishing their wares, a monumental contribution to the world history of ceramics. It is done by carving the desired patterns on the surface of the half-dried body of a vessel, filling the crevices with clay of different colors, covering the surface with glaze, and then firing.

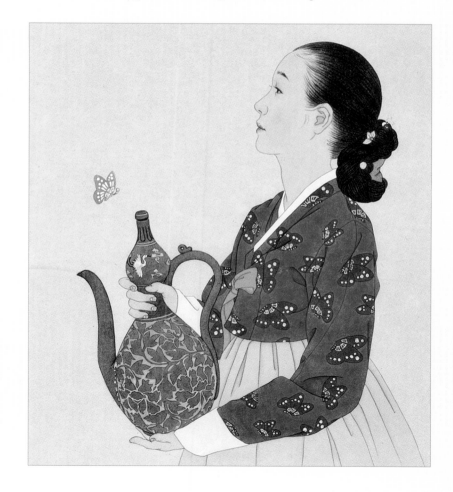

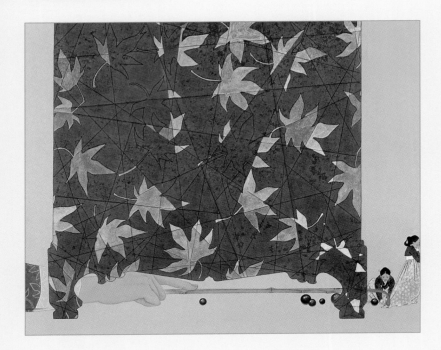

자개장롱 Wardrobe chest inlaid with mother-of-pearl (jagae jangnong)

장롱은 옷 따위를 넣어두는 '장'과 '농'인데, 자개를 박아 꾸미고 옻칠을 한 장롱을 자개장롱이라 한다. 자개는 금조개 껍데기를 썰어낸 조각으로 빛깔이 아름다워 여러 가지 모양으로 가공하여 가구를 장식하는 데 쓴다.

Wardrobe chests come in two types: *jang*, a vertical chest; and *nong*, stacked chests. Both types are tiered with front doors, so they are similar in appearance. These wooden chests are lacquer coated and inlaid with abalone shell strips creating beautiful iridescent patterns.

경상輕床 Sutra table (gyeongsang)

원래 사찰에서 스님들이 사용한 책상이지만, 사랑방에서도 작은 책상인 서안書案 대신 사용하였다. 상의 양 끝이 감겨 올라가 있어 두루마리나 병풍처럼 접힌 책이 굴러 떨어지는 것을 막아주었다. 직선적인 서안에 비해 장식적이며 화려한 느낌을 준다.

Tables of this type were originally used by monks at Buddhist temples, but men of the nobility also used them instead of reading tables in their study-cum-reception rooms, or *sarangbang*. These tables look more luxurious than ordinary reading tables, called *seoan*, which are smaller and made with simple, straight lines. The rolled-up edges with sculpted trim are functional as well as aesthetic: they keep scrolls and folded books from sliding and falling off the table.

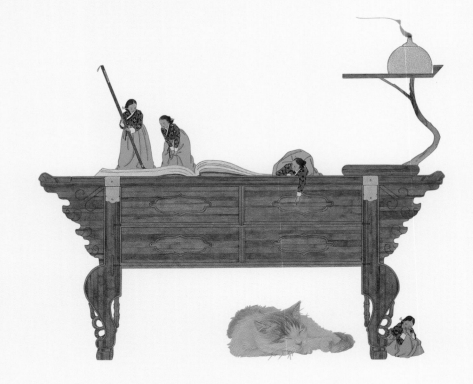

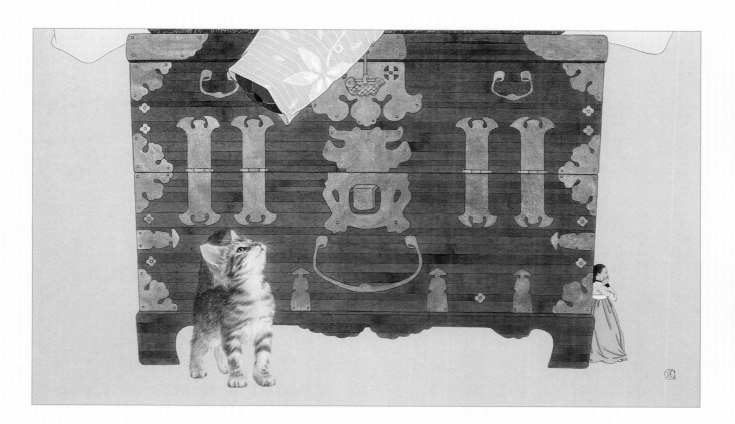

머릿장 Headside chest (meoritjang)

머릿장은 방의 머리맡에 두고 손쉽게 사용할 수 있도록 만든 단층장이다. 천판 위에는 아끼는 물품들이나 작은 물건을 올려놓기도 하였다. 사랑방에서 사용한 머릿장은 천판 아래에 서랍을 설치하고 그 아래에 여닫이문을 장치한 공간을 만들어 물건을 보관할 수 있도록 하였다.

A bedside chest with a front flap door is placed in women's rooms to store articles like socks and sewing box for convenient use. Small things, such as decorative objects, are put on top. Similar chests for the men's study have drawers beneath the top panel and the space below is accessed through a hinged front door.

장석裝錫 Metal fittings (jangseok)

일정한 기능을 하도록 목가구에 부착하는 금속 장식을 말한다. 장석은 문을 여닫거나 물건을 들어 옮기는 등의 기능과 목재의 결합 부분이나 모서리에 힘을 보강해 주는 기능뿐만 아니라 목가구의 아름다움을 돋보이게 하는 장식의 효과도 있었다. 무쇠, 주석, 백동과 같은 재료를 사용하였으며 복을 기원하는 박쥐무늬나 수壽, 복福과 같은 글자를 새겨 넣기도 하였다.

Made of iron, brass, nickel or tin, the metal fittings of wooden furniture reinforce their structure by securing joints and corners, and help open and close them. They are often incised with auspicious designs, such as bats, butterflies and Chinese characters symbolizing longevity and happiness to outstanding decorative effect, enhancing the beauty of the otherwise simple wooden furniture pieces.

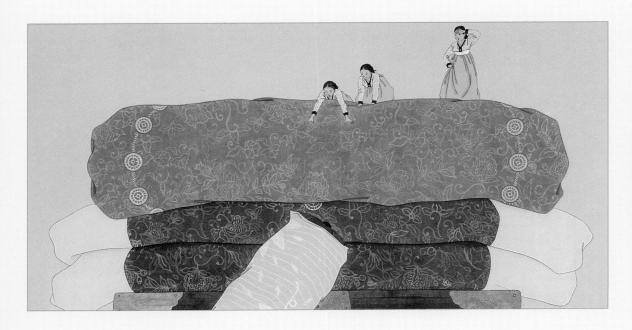

금침 Bedclothes (*geumchim*)

금침은 좌식생활을 하는 한국의 전통 침구다. 사람이 앉거나 누울 때 배기지 않도록 방바닥에 까는 요, 잘 때 몸을 덮는 이불, 누울 때 머리를 괴는 베개로 이루어져 있다. 이불과 요를 '이부자리'라 하고, 이부자리와 베개를 모두 합쳐 '금침'이라고 한다.

Koreans sleep on a cotton-padded mattress (*yo*) spread on the heated floor (*ondol*), covering themselves with a comforter (*ibul*) similar to the Western duvet, either padded with cotton for warmth in winter or lined with fabric in summer. A typical set of beddings, called *geumchim*, consists of these items and a pillow (*begae*). *Ibujari* refers to a mattress and a comforter.

자수 Embroidery (*jasu*)

자수는 바탕천에 그림이나 글자, 문양 등을 그려서 아름다운 색실로 곱게 수를 놓는 것을 말한다. 한국 전통 자수는 크게 신앙심을 나타내기 위해 제작된 불교 자수, 풍경화나 풍속화, 십장생 등을 수놓았던 병풍 자수, 의복을 꾸미거나 신분을 나타내기 위한 복식 자수, 이부자리나 방석, 부채, 복주머니, 장신구 등에 쓰이던 생활 자수 등으로 나눌 수 있다.

Embroidery is the handicraft of decorating fabrics and other materials with pictures, letters or patterns rendered with needle and thread. In Korea, embroidery has traditionally been applied to Buddhist ritual objects, folding screens, garments, personal ornaments, and various everyday items such as beddings and cushions, fans, and purses. Embroidery patterns on clothes often denoted the wearer's social status. Symbols of longevity and happiness are also favored motifs.

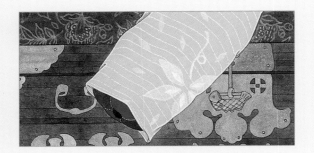

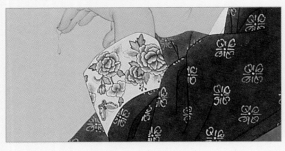

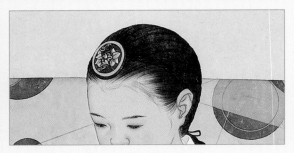

단오 Double Five Day (Dano)

전통 명절의 하나. 음력 5월 5일로, 단오떡을
해먹고 여자는 창포물에 머리를 감고 그네를 뛰며
남자는 씨름을 한다.

One of Korea's traditional holidays, Dano falls
on the fifth day of the lunar fifth month. On this
day people eat mugwort rice cakes; women wash
their hair with water soaked with sweet iris
leaves and enjoy swing rides; the men enjoy
wrestling contests called *ssireum*.

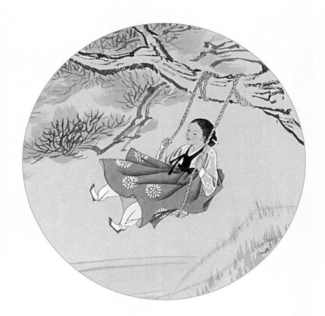

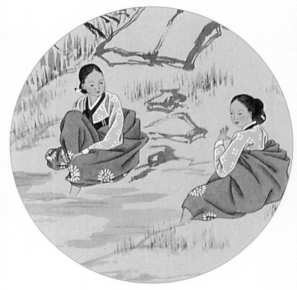

공기놀이 Pebble game (*gonggi nori*)

공기라고 불리는 놀잇감을 사용하는 한국의 민속놀이다. 공기는
놀이에 쓰이는 자그마한 크기의 물체를 부르는 말로, 대부분은 작고
비슷한 크기를 지닌 돌이다. 공기놀이는 일반적으로 다섯 개의
공기를 이용하며, 서양의 너클본스^{knucklebones}와 비슷하다.

This is a folk game played with small objects called *gonggi*, most
often five pieces but sometimes more. Pebbles of similar sizes were
used in the old days. The game is similar to the old traditional
Western children's game of knucklebones or jacks.

Explanation of her work

The Subtle Borders between Past and Present, Reality and Imagination

Shin Sun-mi uses traditional techniques in her art but she has overcome the triteness all too common in traditional Oriental painting and expanded the scope of her time frame by exploring modern themes.

Human figures are prominently highlighted in her paintings in which elements of contradictory natures are deftly harmonized through depiction using techniques of animation, eliminating disbelief. Women dressed in elegant *hanbok* lounge around engrossed with their smartphones, cute little children and elfin fairies regard each other playfully or distractedly, echoing the reality of our times when the past and the present coexist.

Numerous imaginary fairies, called *gaemi yojeong* ("ant fairies") are deployed to help expand time and space in Shin's paintings. Child rearing is another favorite theme of her paintings depicting everyday life. A child symbolizes the great human function of reproduction and expansion; hence a child reflects the artist's past, present and future. Under the premise that only children with pure hearts can see the ant fairies, the children in her paintings are intermediaries connecting the realms of reality and imagination.

Shin Sun-mi doesn't simply adopt children as her motif but hides their mischievousness in her works. While the children, or the women, are asleep, the fairies keep moving around briskly; the viewer is the only one who perceives this situation. In her "Pattern Stories" series, Shin further adds to the tension of her work by introducing views from above. The human figures impart even more secret thrills upon discovery, as they are depicted as if they were hiding inside traditional patterns.

A child turns his back on the diminutive fairies from time to time, distracted while playing with them. The fairies want to get his attention back, but he is mesmerized by the numbers on a receipt and the screen of his mobile device. The child is imitating adults addicted to modern technology, a common pattern of behavior among children today. There also are adults gazing at elfin fairies as if they represent the artist's longing for purity that is ever vanishing in our days. These adults are given the ability to see fairies, who belong to a realm that can only be perceived by children, embodying the artist's wish to return to her childhood and be reunited with her playmates of those bygone days. Through her work spotlighting the enchantments lost to our times of advanced technology when the internet and smartphones take the place of direct, person-to-person communication, the artist presses us to look askance on the mores of contemporary society and restore purity that is being forgotten.

Park Soo-jin
Curator, Gallery Sun Contemporary

작품 해설

과거와 현재, 현실과 가상 사이의 기묘한 경계

작가 신선미는 작품에서 전통 기법을 구사하지만 현대적 주제를 다룸으로써 동양화의 통속성을 극복하고, 시대의 확장을 이뤄냈다.

생동감 있는 묘사로 상반된 요소의 융합에도 괴리감이 느껴지지 않는 그녀의 작품들을 살펴보면 유독 인물을 강조하고 있음을 발견하게 된다. 핸드폰 조작에 빠져있는 한복을 입은 여인들과 아이, 그 주변을 맴도는 개미요정들의 모습은 과거와 현재가 공존하는 현 시대의 모습과도 닮아있다.

과거와 현대의 결합으로 시대적 확장을 보여주는 작품에 작가는 '개미요정'이라는 가상의 인물 집단을 투입시켜 시공간의 확장을 꾀한다. 사람 손바닥 크기의 개미요정들의 세계는 그림 안에서 인간 세계와 만나 결합한다. 작가가 일상을 주제로 한 작품에서 특히 '육아'는 빠질 수 없는 소재다. 인간이 누릴 수 있는 가장 위대한 확장인 출산으로 얻은 아이는 작가 자신의 과거와 현재, 미래를 반영한다. 또한 순수한 마음을 가진 어린 아이만이 개미요정을 볼 수 있다는 설정은 그림 속 아이가 인간과 개미요정, 즉, 현실과 가상을 이어주는 매개체임을 말해준다.

신선미는 아이를 주요 소재로 활용할 뿐 아니라 아이들이 가진 특성인 장난스러움을 작품에 숨겨놓았다. 아이 또는 여인이 잠든 사이 개미요정들은 몰래 일을 꾸미듯 바쁘게 움직이고, 그 모든 상황을 아는 사람은 관객뿐이다. 〈문양이야기〉 시리즈에서 신선미는 위에서 아래를 내려다보는 긴장감 있는 구도를 선보였다. 이 구도 역시 그림 속 인물들은 주변에서 일어나는 일을 고개를 돌려봐야만 알 수 있는 반면, 관객은 위에서 모든 정황을 한눈에 살필 수 있다. 또한 그림 속 인물들이 전통 문양 속에 숨어있는 듯 표현되어 한층 더 비밀스럽고 흥미롭다.

작품 속에서 개미요정들과 유희를 즐기던 남자아이는 시간이 지나며 이따금 그들을 외면한다. 요정들은 관심 받길 원하지만 아이는 영수증에 나열된 숫자나 휴대 기기의 화면에 시선을 빼앗기고 있다. 문명에 젖은 어른을 모방하고 있는 이 광경은 작가 스스로 바라본 요즘 아이들의 행동 양식을 투영한 결과다. 순수성을 잃어가는 시대에 대한 아쉬움의 표현으로 작가는 개미요정을 바라보는 어른의 모습 또한 작품에 등장시켰다. 본래 어른들은 인지할 수 없었던 개미요정들을 보게 함으로써 그들 또한 어린 시절로 돌아가 동심의 대상과 재회하기를 바라는 작가의 마음을 담았다. 기술이 진보하며 인터넷이나 핸드폰으로 더욱 손쉽게 연결될 수 있음에도 직접적인 소통은 오히려 줄어드는 그 이면들을 작가는 작품들을 통해 조명하며 현 사회의 세태에 잊혀져 가는 순수성을 회복하기를 권유한다.

박 수 진
갤러리 선 컨템퍼러리 큐레이터

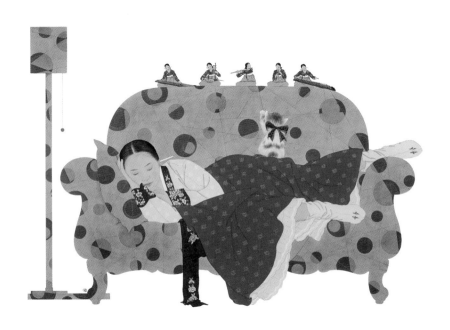